IMAGES
of America

CEMETERIES OF
CARSON CITY AND
CARSON VALLEY

HISTORIC CEMETERIES

The key to this map of Carson City and Carson Valley Cemeteries is as follows: 1. Captain George, 2. Empire City, 3. Fredericksburg, 4. Garden, 5. Genoa, 6. Glenbrook, 7. Jacks Valley, 8. Elzy Knott, 9. Lone Mountain, 10. Mottsville, 11. and 12. Nevada State Prisons, 13. Pioneer, 14. Ormsby County Poor Farm, and 15. Stewart Indian School. (Southerland Studios.)

ON THE COVER: At Lone Mountain Cemetery in Carson City, the three surviving members of the Grand Army of the Republic pay their respects to fallen comrades during a Decoration Day ceremony around 1917. The men are posed near the Civil War monument that was erected in 1891 to honor the memory of Union soldiers and sailors. (American Legion Capital City Post No. 4, Carson City, Nevada.)

IMAGES
of America

CEMETERIES OF
CARSON CITY AND
CARSON VALLEY

Cindy Southerland

ARCADIA
PUBLISHING

Copyright © 2010 by Cindy Southerland
ISBN 978-0-7385-8106-4

Published by Arcadia Publishing
Charleston, South Carolina

Printed in the United States of America

Library of Congress Control Number: 2010929342

For all general information, please contact Arcadia Publishing:
Telephone 843-853-2070
Fax 843-853-0044
E-mail sales@arcadiapublishing.com
For customer service and orders:
Toll-Free 1-888-313-2665

Visit us on the Internet at www.arcadiapublishing.com

*This book is dedicated to Shiloh the Wonder Dog,
woman's best friend and boon companion.*

CONTENTS

ACKNOWLEDGMENTS

My heartfelt thanks and appreciation to all who assisted with the compilation of photographs, information, and moral support for this book: Bob Nylen and Sue Ann Montelone, Nevada State Museum; Jeff Kintop and Baylen Limasa, Nevada Library and Archives; Jacquelyn Sundstrand and Joel Guldner, University of Nevada Reno Special Collections; and Lee Brumbaugh, Michael Maher, Eric Moody, and Phil Earl, Nevada Historical Society. Many thanks for information and encouragement to sextons Tim Glancy and Dave Stultz, and to the memory of Betty Denison at the Lone Mountain Cemetery. Special appreciation to Alan Glover and staff at the Carson City Assessors Office; David Davis and Jeffrey Vaillant, Sons of Union Veterans of the Civil War; historians Kani Shannon, Bill Bliss, and Shawn Hall; Frank Adams, Nevada Law Enforcement Officers Memorial Commission; Wally Adams, Genoa Cemetery Association; Ellen Martin, Douglas County Historical Society; Sue Ballew, Carson City Historical Society; and to Yvonne Prettyman, Carol Clifford, and Chic DiFrancia, technical support. A special word of thanks and gratitude for the support, encouragement, and tenacity to see me through this book must be given to my husband, Doug. To my editor at Arcadia Publishing, Debbie Seracini, your support and encouragement has been invaluable.

All photographs and maps are courtesy of the author unless otherwise noted. Other sources include the Library of Congress (LOC), Nevada State Museum (NSM), Nevada Historical Society (NHS), University of Nevada Special Collections (UNRSC), Carson City Assessor's Office (CCAO), Douglas County Historical Society (DCHS), and Warren Engine Co No. 1 (WECNO1).

INTRODUCTION

*In order to know a community, one must observe the style of its funerals
and know what manner of men they bury with most ceremony.*

—Mark Twain, *Roughing It*, 1872

The communities of Carson City and Carson Valley encompass a diverse group of small towns, the state capital, and several historic sites where today nothing remains to remind one of a community—except for a cemetery. Carson City, the state capital, was created by Abraham Curry and partners in 1858. Curry is regarded as the "Father of Carson City" and was responsible for developing a sparsely populated area first into the territorial capital (1861) and then the capital of the new state of Nevada (1864). From his sandstone quarry located on the eastern side of town, Curry supplied building materials for construction of the capitol, the U.S. Mint, the prison, the Virginia and Truckee Railroad engine house, and other buildings in town, as well as provided material used to fabricate headstones used in area cemeteries. Many of Carson's cemeteries contain monuments crafted from Curry's sandstone, including the two cemeteries on the grounds of the Nevada State Prison.

Also within the boundaries of Carson City is the site of Empire City, an ore-milling town built along the banks of the Carson River. Between 1865 and 1875, Empire was a thriving community of 750 hardy souls, with a school, merchants, saloons, and a hotel run by Dutch Nick Ambrose. Empire was in decline by the 1880s, and in 1960, only one caretaker family remained. The little town is now buried beneath a golf course, and the small cemetery rests on a hilltop next to a cement plant. Other cemetery sites within the Carson City community include Pioneer, Stewart Indian School, and the Ormsby County Poor Farm.

In Carson Valley, Genoa is the oldest community, founded in 1851 by John Reese as Mormon Station, the first permanent trading post established in western Utah Territory. In 1861, the area became known as Nevada Territory and Genoa was designated as the Douglas County seat. By 1916, the county seat had been moved to Minden. The original Mormon Station was destroyed by fire in 1910, and a replica was constructed in 1947. Today the replica serves as an interpretive site and museum. There are two cemeteries in Genoa, with one being the main site, created on land deeded to the town by James Haines in the 1860s. Many early settlers are buried here. One of the best known is John A. Thompson, better known as Snowshoe Thompson. The other cemetery is a lonely one, isolated from the main cemetery by choice, not necessity. That story is told in the fourth chapter of this book.

The town of Gardnerville was formed by Lawrence Gillman in 1878. He moved the Kent Hotel from Genoa to a 7-acre site he purchased from John M. Gardner. He renamed the building the Gardnerville Hotel and christened the town Gardnerville in honor of the man who sold him the property. A thriving community soon grew up around the hotel, attracting emigrants from

Germany and Denmark, and later, arrivals from the Basque countryside of France and Spain. The Garden Cemetery is located in Gardnerville and is surrounded by a sea of houses and apartments. Founded in 1898, the newly-formed cemetery association purchased land from Mathias Jepsen for $465 to use as the community burial ground.

In many communities, the only evidence of a settlement is the remaining cemetery. Mottsville, located south of Genoa, was settled in 1851 and at one time boasted a hotel, school, store, gristmill, and a dance hall. The site is famous for many Nevada firsts: first white woman settler in western Utah Territory; first school held in the Mott kitchen; and the first session of the U.S. Third District Court held in the Mott barn. The first grave in the Mottsville cemetery was that of the Motts's third child, Mary Elizabeth, in 1857.

At Jacks Valley, settled by Mormon ranchers in 1853 and a stop on the famous Pony Express route, all that remains is the tiny cemetery located in a grove of pine trees. Here lies John M. Gardner, namesake of the town of Gardnerville.

Over the top of the Sierra on the shore of Lake Tahoe lies the community of Glenbrook. Founded in 1861 when Augustus W. Pray built a sawmill to harvest the plentiful lumber supply, followed by the construction of the Glenbrook Hotel in 1873, the tiny community was a booming site for decades. The wood and lumber products were sent down the hill by V-flume, log floats on the Carson River, and eventually by railroad to supply the needs of the towns and mines of the Comstock Lode. A small cemetery remains at Glenbrook, now a private oasis in the mountains.

Fredericksburg, once a support community for the ranching, mining, and lumbering operations of the surrounding area, now only supports a local cemetery. And the forlorn Captain George Indian Cemetery site is barely visible to the eye as traffic flies by on Foothill Road.

This book is presented in chapters that interpret the final respect shown by the living for the dead. The first chapter focuses on what the tombstones tell us, such as birth and death dates, nativity, ethnicity, religious orientation, fraternal membership, and in many cases, the manner of death. In the second chapter, the symbolism found on the headstones and fencing surrounding the graves is defined. The third and fourth chapters provide detailed information on a selection of the stones and stories of those buried in the cemeteries of Carson City and Carson Valley. The final chapter focuses on Twain's statement that "in order to know a community, one must know what manner of men they bury with most ceremony."

Enjoy your visit to the cemeteries of Carson City and Carson Valley. Remember to take only photographs and leave only footprints.

One

WHAT DO THE TOMBSTONES TELL US?

Why are historic cemeteries important to society today? A visit to a cemetery will soon reveal the reason as the history of the rich and poor, famous and infamous are recorded there, in their original location. The grounds are often the only record or artifact remaining to share the story of the community and the individuals who shaped it. Each tombstone tells a tale that reveals biographical information, historical events, ethnicity, and religious and fraternal association, and in some cases, the cause of death. Tombstones are considered an outdoor archive and may be the last surviving document to record the existence of the person buried there. Most importantly, the stones, markers, and fencing are representative of how Victorian-era people viewed death, mourning, and proper burial of the departed.

Events of personal importance and historical interest are found in the epitaphs and inscriptions on the stones and markers. The epitaphs provide important genealogical information, which may have been lost or destroyed in early written records. The tombstones provide important social and cultural information, ranging from statistics regarding age, sex, ethnic, and religious information, to the causes of death, as well as less direct information, such as the community's attitude towards women.

The accessibility of a historic cemetery allows everyone to view, appreciate, study, and learn from these documents, to admire the artwork and symbolism, and to understand the history of the community. Unlike some museum artifacts, these markers of the past are readily available to everyone. They are valuable educational tools through which the history of the region, its people, and culture impart a sense of the past.

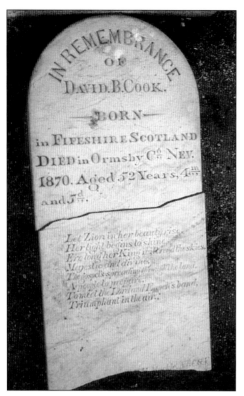

David B. Cook was born in Scotland and died in Ormsby County, Nevada, in 1870. His marker not only provides biographical and ethnic information, but also a beautiful inscription carved by stone mason H. H. Muckle, who etched his name and address on the bottom right edge of the stone. The Cook family is buried in Lone Mountain Cemetery, Carson City.

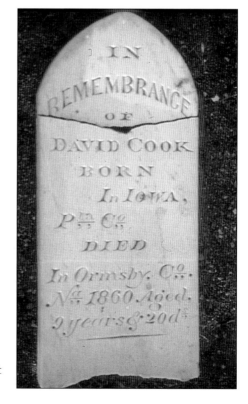

Another stone carved by Muckle for the son of David B. Cook is pictured. Significant here is that young Cook died in 1860, four years prior to Nevada statehood. The stone reflects biographical information and is one of the earliest gravesites in the Lone Mountain Cemetery.

The elaborate stone reads, "In Remembrance of James Cook, son of David B. Cook, born in Scotland . . . killed in Gold Hill Nev by the V. & T. R. R. Aug. 3rd 1872." James Cook's marker in the Lone Mountain Cemetery reveals his nativity, ethnicity, and manner of death. He died while attempting to jump on a moving train car, fell beneath the wheels, and was killed instantly.

From the Glenbrook Cemetery, this view of the stone erected by the Glenbrook Inn employees to commemorate Hank Emmons features a pair of crossed oars. Dates are shown, and research reveals that Hank was the fishing guide at the Glenbrook resort for many years.

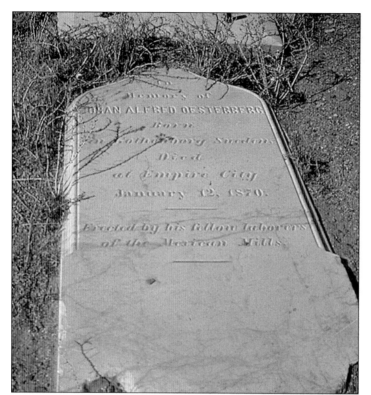

Oesterberg's stone in the Empire Cemetery reads that it was erected by his fellow laborers of the Mexican Mill and displays his place of birth, Sweden. The stone provides biographical, ethnic, and occupational information. He was crushed to death in a milling accident in 1870.

This wooden marker states, "Robert Fowler, native of Manchester England, Died October 9, 1888 on the Overland Train at Laramie Wyoming, interred here October 15, 1888." Fowler died while en route to see his brother who operated a hotel in Carson City. Place of birth, manner of death, and an interesting story are quickly melting away as the wood weathers beyond recognition. This marker is located in Lone Mountain Cemetery.

Religious orientation is shown on this marker that was erected to memorialize two children of the Harris family, found in the Jewish section of Lone Mountain Cemetery. The top portion of their stone is an inscription written in Hebrew, with the lower portion in English. The children were born in Sheridan, Nevada, and died within a few months of each other in 1873.

13

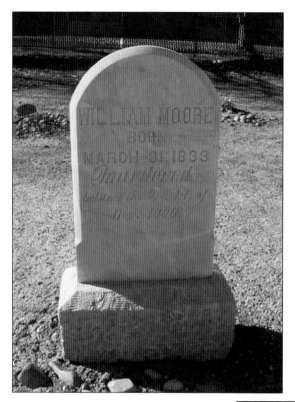

"Murdered between the 9, & 14, of Dec. 1900" reads the marker for William Moore in the Garden Cemetery in Gardnerville. The newspaper reported that he was "murdered by redskins [who] are getting a reputation like unto that of the Apachee." The monument also shows his birth date, 1833. A serial murderer was responsible for many deaths over an 18-month period, and Moore may have been one of his unlucky victims.

The inscription for Johann Hogrefe is entirely in German. It is possible to decipher birth and death dates, age, place of birth, and that the stone was dedicated by his wife. The Hogrefe family owned property along the Hogrefe Slough, located in Carson Valley. He was 28 years of age at the time of his death in May 1879 and is buried in the Genoa Cemetery.

At 45 years old, Jas. R. Vair was killed by a work-related accident at Lake Tahoe. Vair's marker is unique, resembling a tree with branches cut off, which signifies a life cut short. He made his living as a conductor on the Lake Road train and fell beneath the wheels of the locomotive while uncoupling cars. The marker is located in Lone Mountain Cemetery.

The inscription tells the story of the many firsts that occurred in the community of Mottsville, founded in 1851 by Israel and Eliza Mott. This stone at the Mottsville Cemetery memorializes them and asserts "men and women who plant civilization in the desert, who organize emigrants into communities, and throw around them the protection of the law should not be forgotten."

Eliza Mott arrived in western Utah Territory with her husband, Israel, in 1851. Born in Canada, she came to America at the age of 13. Eliza taught school in the kitchen of her house. After her husband's tragic death in a farming accident in 1863, Eliza married her neighbor, A. M. Taylor, in 1864. She died in Mottsville in 1909 at the age of 80 and is buried in the Mottsville Cemetery, but her grave is not individually marked.

On the back of this photograph is written, "First house in Mottsville, cellar built 1857, the rest in 1859. First school in Mottsville held in kitchen of this old house. Mottsville Cemetery in front of house." (UNRSC.)

This monument was erected to remember the Jones family who settled here in 1865. The family "operated this ranch for the next 102 years, 45 years they operated a freight line up and over the narrow, steep and treacherous Daggett (Kingsbury) Pass." The monument was erected in 1974 by a descendant of the Jones family and is in the Mottsville Cemetery.

Hank Monk was a legendary stage coach driver in the 1870s. One of his most famous rides was driving Horace Greeley to Placerville, California, in the record-setting time of 10 hours. That story was made famous by Mark Twain in *Roughing It*. Hank died in Carson City in 1883 and is buried in Lone Mountain Cemetery. His original headstone was crafted of sandstone from Curry's quarry.

This replacement marker was erected in 1964 and provides biographical, nativity, and occupational information about Hank Monk. The original marker now lays flat on the ground at the foot of the replacement marker, in its original location.

In 1878, Carson City musician and composer John P. Meder wrote the "Hank Monk Schottische." The images on the sheet music depict Hank, his famous stagecoach, and the phrase, "Keep your seat Horace, I'll get you thar on time."

FUNERAL NOTICE.

DIED,

In Carson, Nevada, Feb. 28, 1883,

HANK MONK,

Aged 54 years.

FUNERAL

Will take place at 2 o'clock (Friday) from the Episcopal Church.

Friends and acquaintances respect-fully invited to attend.

This funeral notice was published in the local newspaper for Hank Monk's services. Monk drove stage in both California and Nevada for more than 30 years. (NHS.)

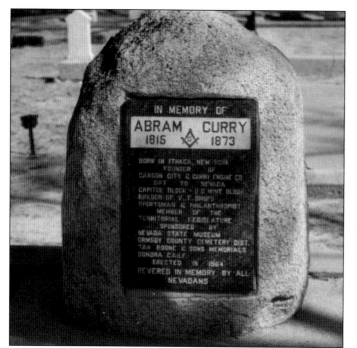

This granite marker erected to honor Abraham Curry was not set in place until 1964 in Lone Mountain Cemetery. Notice the stone reflects Curry's biographical information and many accomplishments, though the stone carver misspelled Curry's first name. At the time of his death in 1873, the Curry family was in financial distress and a proper monument could not be afforded.

Abraham Curry is credited as the Father of Carson City. To promote interest in the town, he offered free lots to those who built and lived in his vision of a town. Curry liked to gamble and once bet on the distance the Curry Engine Company could hand pump a stream of water. Curry, his wife, and several of his children and grandchildren are buried in Lone Mountain, but many lie in unmarked graves. Carson City named Curry Street in his honor.

William Daniels's stone in Lone Mountain Cemetery provides birth and death dates as well as place of birth, but more importantly, it proclaims he was a "Hero of Balaklava." William served with the 63rd British Regiment of Foot and fought at the Charge of the Light Brigade during the Crimean War, a battle immortalized in Alfred Lord Tennyson's poem of the same name. Following his discharge from the British service in 1865, Daniels immigrated to America, soon settling in the Carson City area. Daniels was employed as a shop worker with the Virginia and Truckee Railroad, but it was not until his death that his fellow employees or his wife knew of his military service in the Crimean War. He died in Carson City in 1889.

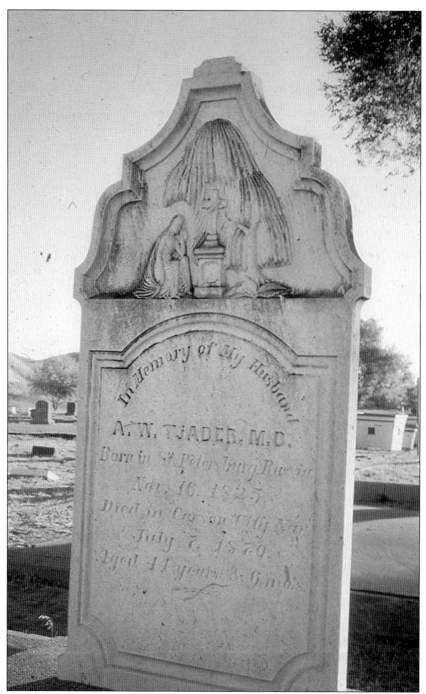

In Memory of My Husband

A. W. TJADER, M.D.

Born in St. Petersburg, Russia
Nov. 16, 1825.
Died in Carson City, Nev.
July 7, 1870.
Aged 44 years & 6 mo's.

Dr. Anton Tjader and William Daniels share a historic, coincidental background. Dr. Tjader also served in the Crimean War, as a surgeon for the Russian Army, and was at the Battle of Balaklava. After arriving in America, Tjader settled in Carson City and married one of Abraham Curry's daughters. At the time of his death in 1870, Dr. Tjader was employed as the physician for the shop workers of the Virginia and Truckee Railroad. He is buried in the Curry family section at Lone Mountain Cemetery.

Two

The Dying Art of Cemetery Symbolism

Symbols on grave markers define otherwise inexpressible ideas and have been used for centuries, dating as far back as Egypt and early China. The symbolic designs and epitaphs found on the headstones represent the transition from the superstitious, dark Puritan beliefs regarding death to the Victorian attitude of "beautiful death," a desirable and long-awaited refuge from the weary world. In historic cemeteries, unique and inspiring examples of how the communities dealt with death and immortality can be found. Themes of grief, sorrow, love, purity, and other virtues are expressed through the use of motifs such as weeping willow trees, roses, draped stones, doves, lambs, ivy, anchors, hands, and crosses. Imagery associated with fraternal groups, like the square and compass or mortar and trowel, symbolizing the desire for a straight, even life held together with the mortar of God (Masons); three interlocked rings representing friendship, love, and truth (IOOF); and the scimitar, crescent, and five-pointed star (Mystic Shriners) can also be found.

Stone carving was a successful career choice, with the carver actually adding his "business card" to the bottom of a stone. Stone carving met the demand for elaborately carved headstones while providing advertising opportunities to attract future customers. The fencing that surrounded the plot was often as expressive as the stones within. Themes such as the lamb, weeping willows, the fleur-de-lis, and eternal flames were incorporated in the cast or forged onto iron fences and gates, as well as on wooden markers.

The following symbols can be found on cemetery stones: anchor (hope); books (book of life); cherubs (guide on life path); crosses (emblem of faith); doves (purity, devotion); draped stones (mourning or loss of member of lodge); eternal flames (flame of life); fleur-de-lies (Christian pilgrimage); gates or doors (entrance to Heaven); hand pointing (heavenly reward, physical, spiritual direction); handshakes (greeting, goodbye, unity, marriage); hearts (love); ivy (immortality, faithfulness); lambs (innocence); logs (Woodmen of the World fraternal society); ropes (eternity, binding, connection); roses (purity, love, a severed stem represents shortened life); and weeping willows (sorrow, mourning).

Representing a messenger from God, guardianship, and adoration, a cherub or angel can be found on the graves of young children. This example of a winged cherub keeps watch on the tiny graves in Babyland at Lone Mountain Cemetery in Carson City. There are two Babyland sites at the cemetery, reserved for babies and very young children who have died in infancy or were stillborn.

The use of flowers originated with Egyptian culture. During the Victorian Era, flowers were used as expressions of beauty, the brevity of life, and different virtues. On the stone for Mary Aileen Jones in the Mottsville Cemetery, a chain of daisies and a single rose adorn the marker. The two small children died within a month of each other in 1898.

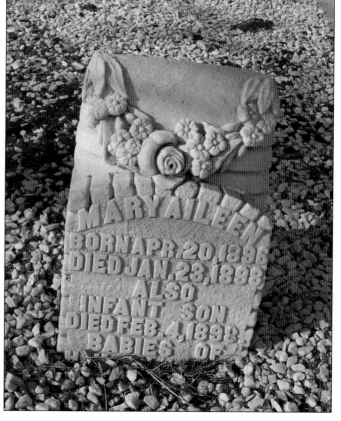

The rose represents purity and love and is frequently seen on the gravestones of women. In Genoa Cemetery, Eliza Todd's headstone features the rose. The shape of the marker symbolizes the "door" to Heaven.

The symbol of the cross is emblematic of faith and has many stylistic variations. The cross honoring Edgar Seamon in Genoa includes the symbolism associated with log monuments, furnished to members of a benefit society known as Woodmen of the World. His cross includes a floral wreath draped near the apex of the cross.

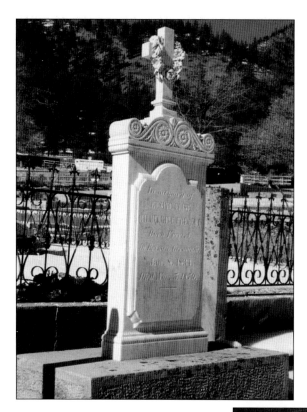

A Latin motif cross adorns the marker erected to Gesine Frevert in Genoa. The Latin cross resembles the letter T, while a Celtic cross is encircled. Mrs. Frevert's cross is adorned with a floral wreath.

One of the easiest stones to recognize is that of carved logs, some with branches cut off signifying a life cut short, all with tree rings of growth on the top section of the carved stones. The fraternal benefit society of the Woodmen of the World (WOW) provided these unique headstones as a membership benefit. Their objective was to "give honorable burial to our sacred dead." Log monuments are also accented with the ivy vine entwined around the trunk and may include evidence of other lodge affiliations, such as the three interlocked rings of the International Order of Odd Fellows (IOOF). This marker is in the Genoa Cemetery. Eldorado Berry was a member of both the IOOF and WOW.

One of the finest examples of the WOW monument was erected for a young boy who had drowned while swimming with friends. Note the sunbonnet resting at the base of the tree stump and the high-button shoes stashed just inside the hollow formed by the tree roots. Cady was just 12 years old when he died on a hot summer day in July 1896. To honor him, his schoolmates wrote a poem that was published in the *Genoa Weekly Courier*. Cady is buried in Genoa.

John Mallet's WOW marker is located in Lone Mountain Cemetery. In addition to the basic WOW symbols, his stone includes a dove with an olive branch, representing peace; an axe, beetle, and wedge, symbolizing workmanship and the progress of culture; and the Latin phrase *duc tacet clamat*, which means, "Though silent, he speaks."

An open book not only symbolizes a place to register the name of the deceased, but also that their hopes and feelings are open to the world and to God. Sarah Cary, wife of W. M. Cary, died in 1867, and her husband chose the book motif to decorate her marker. The stone carver was "Ed. Harper, Carson," according to the bottom right corner of the marker. Mrs. Cary is buried in Mottsville.

The dove is a symbol of purity and peace and is usually found on the headstones of young women. The dove is most frequently seen holding an olive branch in its beak. In the Fredericksburg cemetery, the memorial for Isabella Harvey illustrates a lovely example of the dove. Mrs. Harvey died at age 22.

Edwin Cushing's rounded headstone includes the three interlocked rings, signifying a member of the IOOF, as well as a weeping willow tree. The willow tree represents the mourning and sorrow of those left behind. Cushing's stone is located in Lone Mountain. Cushing was a tin and coppersmith and a member of IOOF Capitol Lodge No. 20 in Carson City. His lodge brothers paid $3,000 from the Lodge benefit fund to his family after his death.

An adaptation of the weeping willow tree is found on the stone of Fredrich Fritsch in Genoa. The urn and willow tree were very popular in 19th-century cemetery sculpture. They represent the transitional period of viewing death as ending in the grave with the Victorian ideal of beautiful death, bringing about a glorious life after departing earth. Fritsch, a native of Germany, operated a grocery in Genoa.

Edward Buckley's stone includes the weeping willow tree and lamb motif. The stone carver left his business card inscription on the bottom left front corner which reads, "J. Sweeney Market St. S.F." Buckley's grave is in the Pioneer Cemetery in Carson City.

A heart-shaped stone, typically placed on a child's gravesite, represents love, courage, and sorrow. Mabel Bohlman died at the age of five and was laid to rest in the family plot in Fredericksburg. Her stone includes the phrase, "Asleep in Jesus."

Clasped hands are usually a symbol of marriage, with the male and female hands clasped in a final loving handshake. Mrs. L. M. Siddons died in 1890 and is buried in Lone Mountain. Her marble marker's shape is symbolic of a doorway to Heaven.

On this stone, erected in memory of David and Mary Jones in Mottsville, is a hand with an index finger pointed to Heaven and the inscription, "In God We Trust." Also note the figure of the man and woman resting against an urn in the center of the stone. The elaborate motif and inscription are indicative of the position of honor and respect for the Jones family patriarchs.

From the Book of Enoch, the lamb, most commonly found on the gravestone of a child or young person, symbolizes purity and innocence. Located in the Garden Cemetery, the bas-relief lamb rests silently on this stone honoring Frederick Sarman. His touching epitaph reads, "Sleep on sweet babe and take thy rest. God called thee home, He thought it best."

This lamb motif found on the marker for Mary Maria Davis also decorates the ornate iron fencing surrounding her grave. Mary was the wife of George Davis, a grocer in Carson City. She was just 24 years old at the time of her death. Her husband is buried in the same plot in Lone Mountain, but his grave is unmarked.

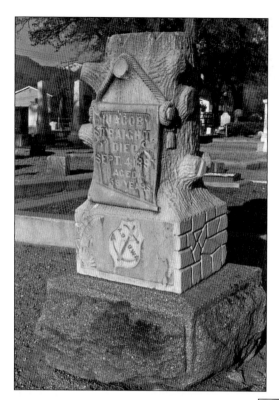

The anchor, a symbol of hope and symbolic of the Ancient Order of United Workmen, is with a cross and heart symbolizing faith and charity. The rope represents a binding connection. This example is found on the headstone of Jacob Straight in Lone Mountain Cemetery, Carson City. According to his obituary, Straight died in 1897 from the effects of drinking too much cold water. He was also a member of the Woodmen of the World fraternal society, as evidenced by the log marker upon which hangs the tablet bearing his information.

Jacob Straight was a member of the Ancient Order of United Workmen. At one time, membership totaled over 300,000; however, there are no active chapters of this fraternal society today.

CONSTITUTION

OF THE

GRAND LODGE OF CALIFORNIA

Ancient Order United Workmen

TOGETHER WITH

Constitution of Subordinate Lodges

—JUNE, 1901—

SAN FRANCISCO
COMMERCIAL PUBLISHING COMPANY, PRINTERS
No. 34 California Street

These symbols reveal that the deceased was a member of The Imperial Council of the Ancient Arabic Order of the Nobles of the Mystic Shrine (AAONMS), founded in 1872 by members of Freemasonry. If the initials AAOMNS are rearranged, they spell "A MASON." The crescent moon represents a world of changing forms and images of paradise; the crown, located on the top of the head, is a sign of success; the cross is a Christian symbol; and the scimitar represents strength and courage. The marker for John Wagner is located in Lone Mountain Cemetery.

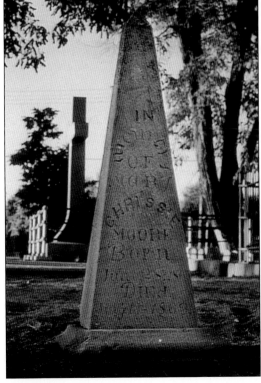

The obelisk is an Egyptian motif that represents a ray of light or symbol of ascension, with its pyramidal point directed to Heaven. The sandstone for this obelisk was furnished by Curry's quarry, located on the state prison grounds. It was placed in the Lone Mountain Cemetery in memory of Mary Chrissie Moore, who died in 1869.

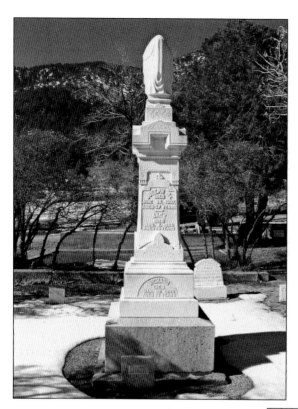

Another example of the obelisk motif was erected on the gravesite of Joseph Raycraft in Genoa Cemetery. The draped urn represents respect for the loss of a lodge brother. Raycraft operated the Raycraft Exchange and Livery Stable, a hotel and dance hall in Genoa.

DIED

At Carson City, Nevada, June 28th, 1907

JOSEPH RAYCRAFT

Age 57 Years

Funeral will take place

SUNDAY JUNE 30th,

at 2 P. M.

From Masonic Hall,

GENOA.

Friends and acquaintences are respectfully invited to attend.

Bereavement or mourning notices were produced by printers to notify the public of the funeral services for a departed member of the community. Families would keep these as a remembrance of their loved one. Raycraft's card states his death and when and where services will take place. (DCHS.)

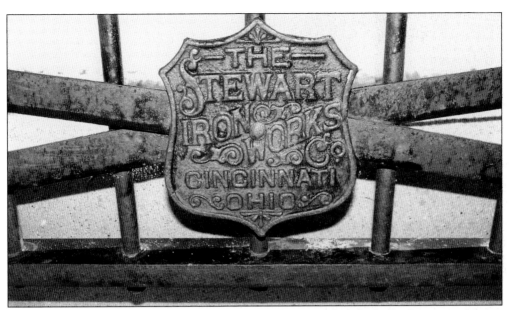

The Stewart Iron Works Company of Cincinnati, Ohio, provided the bulk of cemetery fencing and gates across the nation. Other companies also competed for the market, and the variety of fence styles is one of the more fascinating aspects of visiting a historic cemetery. Variations on the central styles and ornamentation were sold via catalogs provided by Sears Roebuck, Montgomery Ward, and those involved in the funeral business. Cost was driven by what the family could afford, as reflected in those of elaborate and intricate detail to the simpler styles.

Many styles of fencing were offered, as shown in this page from a supply catalog. Various sections and adornments could be added to the final fence, dependent on the wealth of the deceased's family. Many plots were also fenced with wood pickets or planks that deteriorated with time, making them scarce today. (Chicora Foundation, Inc.)

This elaborate fencing design surrounds the plot of Fredrich Fritsch in Genoa. Note the eternal flames on the corners and gateposts, weeping willow trees, and fleur-de-lis.

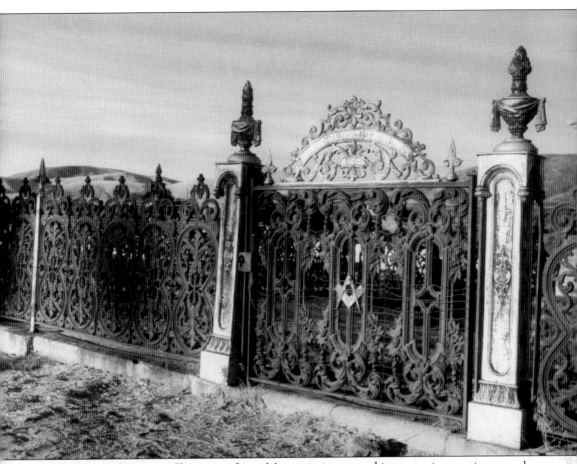

The gravesite of Harrison Shrieves in Lone Mountain is wrapped in expensive cast iron panels depicting traditional symbols of the fleur-de-lis, representative of Christian pilgrimage, and eternal flames on the gate panels, as well as on all corners of the fence. The symbol of the Masons is clearly shown on the gate with the square and compass, while the mortar and trowel emblem symbolizes the desire for a straight, balanced life held together with the mortar of God.

The business side of death emerged during the 19th century as furniture makers began building coffins and providing burial services for the community. This evolved into mourning clothing, stationary, bereavement or memorial notices, the selling of cemetery plots, and links to stone carvers for headstones. Advertisements like these were published in the local newspapers.

This is an advertisement for H. H. Muckle's stone carving business from the *Territorial Enterprise* on March 8, 1872. "Stone and marble works, North C Street, Virginia, Nevada. The undersigned is now prepared to furnish marble tombstones, from $80 upward. Also wooden fences, plain, from $25 upward cast iron railings, of all styles, designs and prices, made to order. Any parties getting up tombstones, monuments, iron railings and fences from below, can have them properly set up in any cemetery at reasonable rates. Building rock from the quarry known as the Swallum quarry, for sale . . . at cheaper rates than it can be purchased anywhere on the coast."

Muckle provided marble tombstones of the finest quality, and his work can be found in many of Nevada's historic cemeteries. His signature was included in the lower front corner of his stones, as seen in these examples.

H. H. Muckle, a native of Ireland, was a stonemason by trade and quickly set up his business in Nevada in 1868. He carved this marble headstone marking the grave of Margaret Fray in Genoa.

From the *Genoa Weekly Courier* on February 1894, M. A. Downey offered "undertaking in all its branches," with the business located opposite the U.S. Mint building in Carson City. (NHS.)

REGISTER OF FUNERALS.

PRESENTED TO

EVERY YEARLY SUBSCRIBER.

CHICAGO, ILLINOIS:

The Western Undertaker,

In 1872, George Kitzmeyer built his furniture factory in Carson City and added coffin and mortuary services a few years later. Kitzmeyer incorporated all the latest management techniques in his mortuary business, including utilizing this *Register of Funerals*, supplied by The Western Undertaker Company. Many volumes of his business registers are located in the University of Nevada Reno Special Collections. (UNRSC.)

Three

CEMETERIES OF CARSON CITY

The cemeteries of Carson City include Lone Mountain, Empire City, Pioneer, the Nevada State Prison, Stewart Indian School, and the Ormsby County Poor Farm. Burials began in Lone Mountain Cemetery in the 1860s, and the site is still in active use. The Pioneer Cemetery, on the western edge of town and in the midst of a residential development, was once the final resting place of Maj. William Ormsby, for whom Ormsby County was named. Most of those buried in the Pioneer Cemetery were reinterred at Lone Mountain. Two cemeteries exist on the grounds of the Nevada State Prison, with the earliest burials dating from the 1870s. In Fuji Park, at the south end of Carson City, are the graves of two Civil War veterans who died while residents of the Ormsby County Poor Farm.

It was not until the 1960s that Lone Mountain Cemetery was created to consolidate numerous plots owned by private individuals, fraternal groups, and mortuaries. The site is located on a busy city street surrounded by housing developments. Across the street from Lone Mountain on a small triangle-shaped section of property is the destroyed segment of the Chinese and indigent cemetery. There is no marker or memorial to those who now sleep under the paved parking lot of a small office complex.

This is a map from the Lone Mountain Cemetery Walking Tour booklet. The cemetery is a 40-acre site and encompasses sections for the Masons, Odd Fellows, Catholics, infants (Babyland), Jews, members of the Grand Army of the Republic, veterans, and a city cemetery section that dates back to the 1860s.

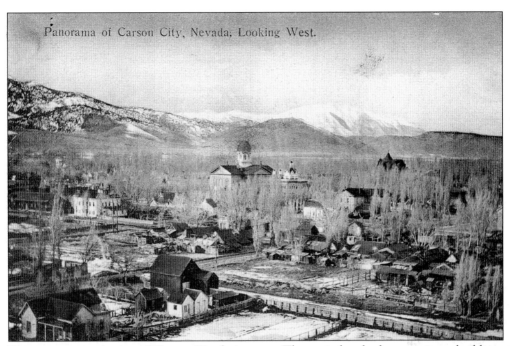

Panorama of Carson City, Nevada, Looking West.

This is a panoramic view of Carson City facing west. The capitol and other prominent buildings can be seen in this postcard view of the town from around the 1880s.

An overview of the cemetery, taken from atop Lone Mountain during the 1880s, is shown here. The photograph indicates a few early fences or sections inside the cemetery boundaries. At this time, the cemetery was under the ownership of local morticians and fraternal societies. No formal cemetery association existed until 1960. (NSM.)

45

The funeral procession for Leopold Stern on Carson Street in front of the capitol on March 26, 1909, is shown here. Stern was a former Ormsby County sheriff and a founding member of the Warren Engine Company No. 1 fire company. He held the position of foreman with the engine company at the time of his death. His funeral procession was one of the largest seen in the capital. (NSM.)

At the 4th of July celebration in 1898, the members of Warren Engine Company No. 1 posed for a photograph before marching in the parade. Leopold Stern is the second man from the right in this image. The parade not only celebrated Independence Day, but also honored those fighting in the Spanish-American War. (WECNO1.)

On the night of June 17, 1908, the Warren Engine Company No. 1 held their 45th anniversary Grand Ball. According to the invitation and order of dances, Leopold Stern served as floor director of the event. (WECNO1.)

John Bath was an early pioneer of western Utah Territory, arriving with his wife, Frances, in 1858. John and his brother Henry started the Bath Ranch on the western edge of town. Bath Street in Carson City commemorates the Bath family for the significant role they played in the community.

John's wife, Frances Maria Fulstone Bath, died in 1910 and was buried in Lone Mountain Cemetery. Her funeral service included many elaborate floral arrangements that were laid upon her gravesite following her burial service.

Abraham Curry's brother-in-law, Joseph Cowen, served on the staff of the U.S. Branch Mint in Carson City as watchman and an assistant in the assay office. (NSM.)

These extravagant floral offerings were created and used during the funeral services for Joseph Cowen. Note the use of the dove symbol, cross, and heart-shaped arrangements. Cowen may be buried in the Curry family plot at Lone Mountain, but no marker has been found. (NSM.)

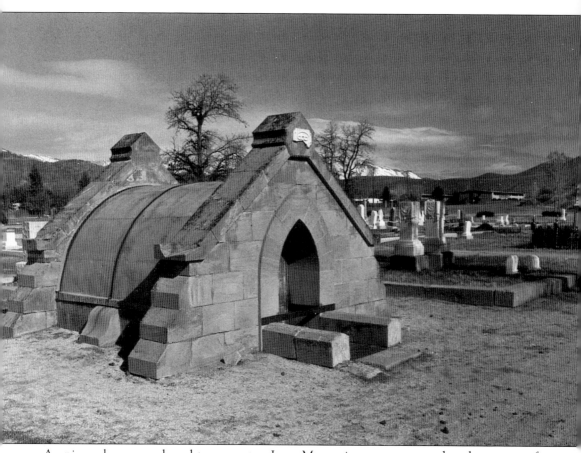

A unique aboveground sandstone crypt at Lone Mountain was constructed at the request of P. H. Clayton who, along with his family, is interred here. Clayton was a "noted secessionist," attorney, and organizer of the Democratic Party in Nevada. After being charged with making disloyal statements against the Union in 1863, his sentence was to carry a 50-pound bag of sand around the parade grounds of Fort Churchill and then take an oath of allegiance before his release from custody. Clayton later served as Curry's attorney on the Board of Regents of Nevada State University and made several unsuccessful campaigns for judge of the Second Judicial Court. Above the doorway of the crypt on a marble plaque are the three rings of the Odd Fellows, with one ring broken, signifying the death of a lodge member. A similar plaque on the back wall simply states, "Our Home." His crypt was severely vandalized in 2000.

In the Catholic section of Lone Mountain Cemetery is the Hoye family plot. Their site includes a handsome iron gate, and the graves are marked with crosses, symbols of their Catholic faith. The Hoye family settled in Smith Valley and operated a toll station and inn along the Walker River. They abandoned the station in 1883 following declines in mining activity and travelers along the toll road.

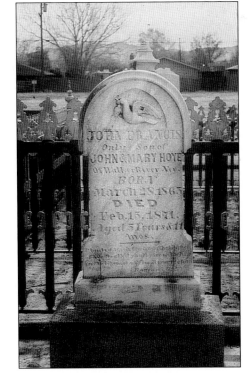

The only child of John and Mary Hoye was born at the Walker River station house in 1865. When he became ill in 1871, his mother drove him by wagon to Genoa for medical help, but the young boy died of Child's Disease (Rotanny Fever). The child's gravestone features a dove and olive branch motif.

Matthew Pixley was a casualty of a notorious prison break from the Nevada State Prison. On the night of September 17, 1871, twenty-nine prisoners made a daring escape, and Pixley, proprietor of the Warm Spring's Hotel that adjoined the prison grounds, was caught in the cross fire of two armed prisoners. A posse was formed and captured a few of the prisoners at a place now known as Convict Lake near Mammoth, California. Pixley was laid to rest in Lone Mountain Cemetery.

The Warm Spring's Hotel was built of sandstone from Curry's quarries, which were located on the grounds of the Nevada State Prison. It was from this porch that Pixley met his death at the hands of escaping convicts in 1871.

George Tufly, native of Switzerland, immigrated to America in the 1850s. By the 1860s, he was settled in Carson City and later owned and operated the St. Charles Hotel. Among his many other civic roles, Tufly was elected Nevada State treasurer in 1882, serving two terms until he retired from office due to poor health. His daughter, Louise, married the young train conductor Harrison Shrieves. (UNRSC.)

GEORGE TUFLY,

State Treasurer.

The St. Charles Hotel was operated by George Tufly from 1865 to 1875. The building has been restored and is still in operation today, featuring a restaurant on the bottom floor and rooms on the top two floors. (WECNO1.)

ST. CHARLES HOTEL,
Corner of Carson and Third Streets,
CARSON CITY, NEVADA. GEORGE TUFLY, Proprietor

Tufly and his wife, Sophia, have matching headstones, both draped as a sign of respect and including symbols of the Masons and Mystic Shriners. There are footstones that indicate the outer edge of the burials, carved with the inscriptions "Father" and "Mother." They are buried side by side in Lone Mountain Cemetery.

The elaborate and effusively carved marble monument erected to Harrison Shrieves is located adjacent to his in-laws, the Tuflys. Harrison was a veteran of the Civil War. After his discharge in 1864, he settled in Nevada, eventually becoming the first conductor of the passenger train service offered by the Virginia and Truckee railroad. He married Tufly's daughter in 1871.

"Harry Shrieves thought to be dying all day from effects of medicine given him by Dr. Stephenson of Virginia City . . . homeopathic Dr .. [sic] gave him big doses of nux vomica by mistake or bad judgment," wrote journalist Alf Doten in 1873. A few months later, Harrison Shrieves died from the effects of the treatment prescribed by that physician. This bottle of medication is labeled Nux Vomica, a derivative of strychnine.

This draped oval stone features the three rings of the Odd Fellows and a couple's hands joined in a final clasp. Isaac Connor was a wheelwright by trade. On a summer day in June 1875, a mule strapped to a wagon that was being repaired moved violently, causing the belt to snap and a lever spring to strike Connor's skull, crushing it. Connor is buried in Lone Mountain Cemetery near the Clayton Mausoleum.

Isaac H. Connor advertised that he could make new wagons and repair old ones "as cheap and in as workmanlike manner as any establishment in the state." Connor was a member of the Warren Engine Company No. 1 firefighters. (WECNO1.)

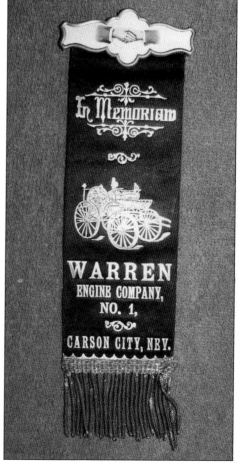

Connor served as a volunteer firefighter with the Warren Engine Company No. 1. The Warren's motto is, "Where duty calls, there you will find us." At his services, his fellow fire company members wore their company ribbons turned over to reveal the back, which read, "In Memoriam." (WECNO1.)

A funeral procession for Isaac Connor would have proceeded north on Carson Street to the cemetery. The procession would have included the members of the lodge or, in this case, the fire company leading the group, followed by the horse-drawn hearse, and then family members. This photograph may have been taken at the procession for Connor in 1875. (NHS.)

Empire City Cemetery sits on the crest of a hill alongside a busy highway corridor and is abutted next to a cement plant. This early plat survey map reflects the cemetery boundary lines. (CCAO.)

The townsite of Empire City was built on the banks of the Carson River and flooded several times during its existence. Today the site is a golf course.

Caroline Webber's sandstone marker in Empire City Cemetery includes a heart on its base. The inscription was spelled phonetically, with numerous misspellings evident, but the sentiment and loss can still be felt. Unfortunately the stone was stolen by vandals and all that remains is this image taken in 1990.

The Stadtmuller plot is centered on top of the hill in the Empire City cemetery. Note the large stone on right that contains a unique bas-relief three-quarter portrait of F. D. Stadtmuller.

F. D. Stadtmuller was a pioneer merchant and banker who arrived in the area in 1852. This 1878 advertisement reflects Stadtmuller as a trustee of the Carson City Savings Bank.

Located at the west end of Carson City is the site of the Pioneer Cemetery. This plat map, clearly illustrating the location of the "Burying Ground," was recorded in the Ormsby County Assessors office on March 12, 1865. The property was originally part of the Welsh Ranch. (CCAO.)

The Pioneer Cemetery site today lies behind a row of residences. There are a handful of markers remaining and many depressions that indicate gravesites. Most of the burials were reinterred in the cemetery that would later become known as Lone Mountain.

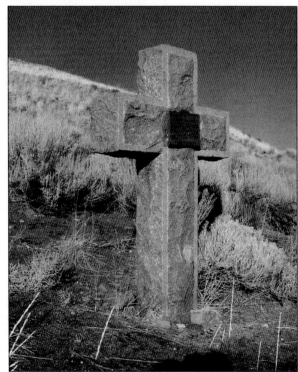

This granite cross stands as a silent guardian over the pioneers who are still buried in this small cemetery. The plaque honors Maj. William Ormsby and William Allen, both of whom were killed in 1860 in the Pyramid Lake War.

Maj. William Ormsby, for whom Ormsby County was named, arrived in the area in the 1850s. He built the Ormsby House Hotel. In May 1860, Ormsby led a militia against a large Pauite war party. Ormsby was killed and his remains were returned to Carson City for burial. However, his body was moved twice before he was laid in his final resting place in New York City in 1907.

William S. Allen was born in Missouri in 1828. His early history is lost in time, but this monument shares his story: "Sacred to the Memory of William S. Allen of Callaway County Mo. born October 25, 1828, and shot by Indians, near Pyramid Lake while at the head of a scouting party, called out by Col. Hayes, June 5, 1860." Allen was the last man to fall at the battle of Pyramid Lake in June 1860. An observer of Allen's death wrote his family that "Will was killed [and] he dropped at my feet and never spoke, there he died, one of the bravest, truest hearted men that ever trod the soil of Nevada." (NHS.)

One of the few remaining stones at the Pioneer Cemetery records the burial site of John Cronin. The sandstone marker reflects the harsh environment and neglect that has plagued this little cemetery in the sagebrush.

Ormsby Co. Nevada Poor farm, at Clear Creek, 3½ miles South West of Carson. Supt Abrahams on the porch and The matron, Mrs Abrahams Standing in the yard.

The Ormsby County Poor Farm was located on the southern end of Carson City and operated as a home for the indigent from the 1860s until its closure in 1965. (NSM.)

The Poor Farm closed in 1965 and a city park was created on the site. All that remains of the Poor Farm are the graves of two Civil War veterans who resided at the farm. Relocating the graves has been discussed over the years; however, the two men still rest under the shade of old trees, with a shopping center to the south, a casino to the north, and a fishpond east of their burial site.

John Thoroughman enlisted in Dayton, Nevada, in 1863 and got out of the service in 1866. He was admitted to the Poor Farm in about 1907. Born in Ohio, he died a pauper at the Poor Farm on December 19, 1909.

James Johnson, also a native of Ohio, enlisted in California in 1865 and only served eight months. Johnson moved to Carson City in 1870 and worked on ranches in the vicinity. Admitted to the Poor Farm in 1909, he left and came back of his own accord several times prior to his death in April 1910.

An overview of the Stewart Indian School cemetery, located across from the former Native American boarding school. Buried here are former teachers, students, and others who were affiliated with the school. The state historical marker at the cemetery gate reads, "Myriads of Stars shine over the graves of our ancestors," which is the name of one of the baskets woven by the Washo basket weaver Dat So La Lee.

Dat So La Lee, the famous Washo basket maker, created exquisite basketry that was marketed through Abe Cohn at his Emporium store for 30 years, from 1895 until her death in 1925.

The marble monument erected to honor Dat So La Lee lists her as the "famous Washo basket maker." Examples of her work can be seen in museums located in Reno, Carson City, and Genoa. She reportedly requested that her last unfinished basket be buried with her. She is buried in the Stewart Indian School cemetery.

An 1873 advertisement offering Nevada State Prison sandstone for "gravestones & monuments cut and lettered" is pictured. Many of the headstones in the local cemeteries were crafted from the sandstone quarry located inside the prison, including those used for burials within the prison walls.

DRESSED STONE FOR SALE!

DRESSED SAND-STONE FOR sale in quantities to suit at the

NEVADA STATE PRISON.

Gravestones & Monuments

CUT AND LETTERED,

And Building Stone, in the rough,

FOR SALE!

P. C. HYMAN,
Warden of the Nevada Penitentiary

Carson, April 5, 1873. ap6 tf

"Nevada State Prison, Carson City, Nevada"

The Nevada State Prison in Carson City includes the Warm Springs site and the original Fifth Street facility. The oldest buildings are still in use today. A postcard view dating about 1925 shows one of the historic sandstone buildings and its gate.

According to an article from the *Nevada State Journal* in 1960, the prison cemetery began in 1862 and was used to bury prisoners who died during incarceration. The property was actually not owned by the state until 1960, and there were 58 burial plots identified as of that date. This photograph is dated 1960.

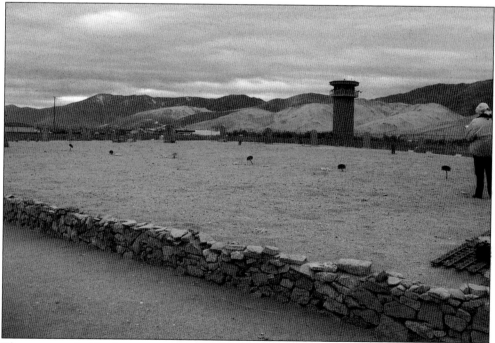

The cemetery inside the prison is gated and fenced, and a guard tower rises above the southwest corner of the site. Note the stone perimeter border and a section of an iron jail door lying on the ground. There are 28 gravesites that are identified and probably more that are forgotten.

Charles C. Petty was convicted of murdering his wife and sentenced to hang. Rather than face the noose in 1910, Petty climbed the light pole in the prison exercise yard and, with a crowd watching, jumped head first to the ground below. His marker is made of prison sandstone and carved into a heart motif.

In 1952, the prison warden noted that many of the graves were unmarked, so he ordered an inmate to sculpt headstones. The man created busts with generic faces since he did not have photographs of the deceased. He produced 50 headstones like the one seen at left. The project was quickly scrapped, with only one remaining example now on display at the Nevada State Museum in Carson City. (NSM.)

At the oldest prison site is the prisoner cemetery, with burials dating from the 1870s. This photograph is dated 1960, prior to the site being cleaned up and fenced.

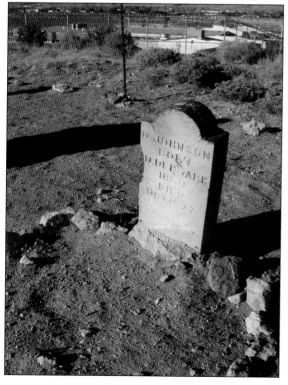

Ole Johnson shot and killed a man in Nye County, Nevada, during an argument over $26 in 1875. Johnson was sentenced to 25 years in prison. While attempting to escape in October 1877, Johnson was shot 27 times by prison guards. This event seemed to quell the outbreak, according to the newspaper's account of the escape attempt.

Historic cemeteries often reveal the country where the person was born, but the marker of L. Rogers within the prison cemetery claims he was "born at sea." Rogers received a three-year sentence in 1878 for committing a felony but died from the effects of "imprudence in eating," according to the warden's annual report for 1880.

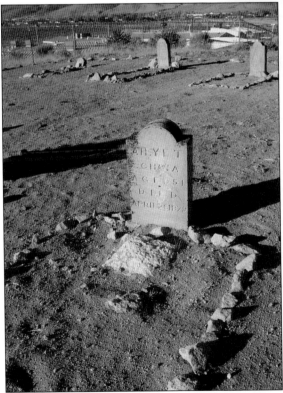

Ah Yet, native of China, was arrested and sent to prison for burglary in 1878. According to the warden's report, the "Chinaman died of valvular disease of the heart" at the age of 51 in April 1879.

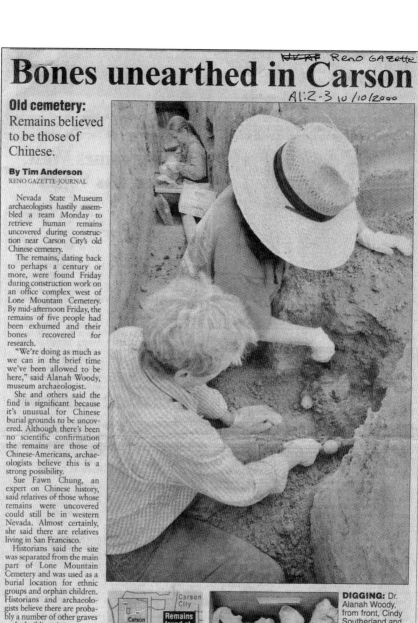

Bones unearthed in Carson

Old cemetery:
Remains believed to be those of Chinese.

By Tim Anderson
RENO GAZETTE-JOURNAL

Nevada State Museum archaeologists hastily assembled a team Monday to retrieve human remains uncovered during construction near Carson City's old Chinese cemetery.

The remains, dating back to perhaps a century or more, were found Friday during construction work on an office complex west of Lone Mountain Cemetery. By mid-afternoon Friday, the remains of five people had been exhumed and their bones recovered for research.

"We're doing as much as we can in the brief time we've been allowed to be here," said Alanah Woody, museum archaeologist.

She and others said the find is significant because it's unusual for Chinese burial grounds to be uncovered. Although there's been no scientific confirmation the remains are those of Chinese-Americans, archaeologists believe this is a strong possibility.

Sue Fawn Chung, an expert on Chinese history, said relatives of those whose remains were uncovered could still be in western Nevada. Almost certainly, she said there are relatives living in San Francisco.

Historians said the site was separated from the main part of Lone Mountain Cemetery and was used as a burial location for ethnic groups and orphan children. Historians and archaeologists believe there are probably a number of other graves at the building site.

Carson City's history is marked by a sizable Chinese population — the largest of any community in the state for much of the latter half of the 19th century. State archivist Guy Rocha's research of census data shows 697 Chinese lived in Carson City in 1870 — about 23 percent of the city's total population.

Woody said development on the 1.5-acre, tri-

angle-shaped site along Roop Street is scheduled to

Remains found at historical burial grounds

Carson City

Winnie Ln.

David St.

Lee St.

Roop St.

Moody St.

Lone Mountain Cemetery

Beverly Dr.

N

S. Reich/Reno Gazette-Journal

DIGGING: Dr. Alanah Woody, from front, Cindy Southerland and Jeanette Dieges work to excavate bones, above.

REMAINS: Left, skeletal remains of at least five people were found. This box contains the bones of one.

Photos by
Lisa J. Tolda
Reno Gazette-Journal

See **BONES** on **3A**

Remains of the Chinese cemetery were unearthed in 2000 during excavation work for a new office building in Carson City. The site was located on a triangle-shaped piece of land that had been part of Lone Mountain Cemetery. It had been forgotten and abandoned for decades prior to its desecration by a backhoe.

This is a depiction of a Chinese funeral from an early publication. The scene shows the bodies ready for interment, a priest using incense to bless the funeral, and mourners bearing gifts of food, traditionally left on top of the grave. This image is annotated as occurring at Lone Mountain. (NSM.)

This 1980 map illustrates the Chinese section and its proximity to the main cemetery. It is unknown how many burials were interred here. Once the remains were removed from the trench, they were sent for scientific study; however, the author has not seen a final report as of the date of publication. The bones will eventually be returned to Lone Mountain Cemetery for reburial. (CCAO.)

Between 1870 and 1950, Carson City's Chinatown population ranged from a high of 802 in 1880 to only 6 people in 1950. A few buildings, including the Chinese Masonic Hall, remained in the 1940s. In 1960, the last remnants of Chinatown were razed to make way for state offices. The actual site of Chinatown was disputed for years but is believed to be buried beneath the state supreme court building, legislative mall, and a parking garage. This postcard view shows only a section of the community that was Chinatown prior to the bulldozer. (NSM.)

Kefer Joseph, farmer, Carson.
Keisel Edward, bds St. Charles Hotel, Carson.
Kellogg A. S., laborer, Carson.
Kelly Daniel, blacksmith, Carson.
Kelly Frank, laborer, Empire.
Kelly Kate, domestic, Corbett House, Carson.
Kelly Patrick, laborer, Empire.
Kelly P. P., constable, Empire.
Kelly P. P., proprietor Nevada Hotel, Main, Empire.
Kelly R. E., clerk (J. Rosenstock), Carson.
Kelly Thos., cook, Carson.
Kelsher James, laborer, Carson.
Kendell M., teamster, Carson.
Kennedy F. B., melter, U. S. Mint, res Minnesota bet
 Seventh and Eighth, Carson.
Kennedy John, res cor Carson and Seventh, Carson.

AH KEE,
Botanical Physician,
OFFICE ON THIRD STREET,
[A short distance East of Carson Street,]

CARSON CITY, NEV.

Successfully treats the most difficult cases of disease, by the use of Medicinal Herbs.
Has cured many patients in town. Persons in need of his professional service, are invited to call at his office.

An advertisement dated around 1877 from the local Carson City newspaper is for Ah Kee, botanical physician, with an office located on Third Street. Ah Kee's practice provided medicinal herbs for the treatment of disease in Carson City from 1870 to 1879. (NSM.)

Four

CEMETERIES OF CARSON VALLEY

Many historic cemeteries are located in the Carson Valley. The Genoa Cemetery site was deeded to the community by James W. Haines in the 1860s, with sections reserved for Masons, Odd Fellows, and town residents. Located behind a modern bed-and-breakfast is the gravesite of Elzy Knott, murdered in 1859 during an argument with a Mormon youth over a bridle. Knott's father refused to have his son buried in the Genoa Cemetery, choosing instead to bury his son on his own property, enclosing the site with a hand-forged iron fence and a fine marble headstone.

On a hillside between Genoa and Mottsville is the Captain George Indian Cemetery burial ground, containing marked and unmarked graves. One of the unmarked sites may be the grave of Indian Joe Pete, accused of murdering Willie Dangberg, son of a prominent Carson Valley ranching family. Joe Pete was captured, convicted, and escaped from jail. He was killed by his own brothers rather than suffer the white man's sentence of justice.

The Garden Cemetery was formed in 1898 on property purchased from Mathias Jepsen for $465. Plots were priced at $15 per family plot, with single plots at $2.50. A visit to the Garden Cemetery reveals one stone that screams, "Murdered between December 9 and 14, 1900."

A cemetery is frequently the only physical evidence of a community, as is the case at Mottsville, Fredericksburg, and Jacks Valley. The Mottsville Cemetery expanded from a family graveyard in 1857. The memorial is inscribed: "Men and women who plant civilization in the desert who organize emigrants into communities and throw around them the protection of the law should not be forgotten."

Fredericksburg, once a support community for Carson Valley and nearby California communities, now only supports a burial ground. The Jacks Valley cemetery provides eternal rest for local ranching families. Here lies John M. Gardner, the namesake of the community of Gardnerville. Glenbrook, a small cemetery nestled in a meadow, memorializes early businessmen and citizens of that Tahoe Basin community.

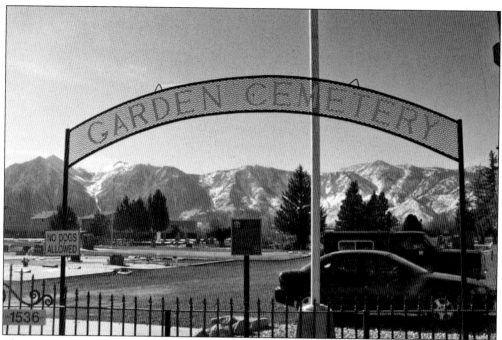

The Garden Cemetery on the border of Gardnerville and Minden is one of the valley's oldest cemeteries. The cemetery is managed by the Garden Cemetery Association.

An overview of the Garden Cemetery reflects its proximity to residential neighborhoods.

Mason Krummes was a founding member of the Garden Cemetery Association and served as the town's undertaker for decades. His business ventures also included a blacksmith shop, built on property now occupied by a casino and parking lot. Mason; his wife, Anna; and other family members are buried in the first section of the Garden Cemetery.

An advertisement for Krummes's mortuary business ran in the *Genoa Courier* in December 1897. It states, "Undertaking, Gardnerville, Nevada. A large and varied stock of caskets, coffins and undertaker's supplies. Only Hearse in Gardnerville."

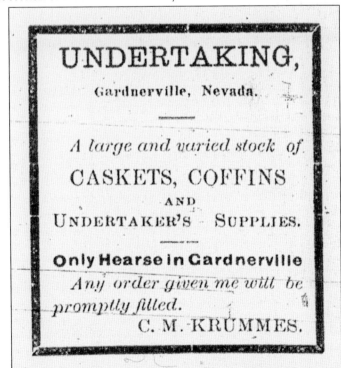

UNDERTAKING,

Gardnerville, Nevada.

A large and varied stock of

CASKETS, COFFINS

AND

UNDERTAKER'S SUPPLIES.

Only Hearse in Gardnerville

Any order given me will be promptly filled.

C. M. KRUMMES.

The new Krummes-Evans hearse is in use at a funeral service around the 1920s in Carson Valley. (UNRSC.)

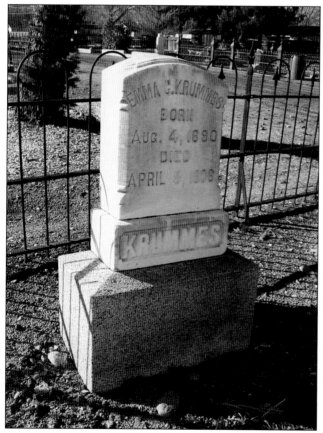

Emma Krummes died at age 15 in 1906. Her obituary stated, "After a lingering illness her sufferings were terminated last Monday by the scythe of the grim reaper and her soul pushed to its place in the blessed realms of heaven."

The bereavement or mourning notice for Emma indicates that "friends and acquaintances are invited to attend" the funeral and interment in Garden Cemetery. She is buried beside her parents. (DCHS.)

DIED

At Gardnerville, Nevada, April 9, 1906
EMMA C. KRUMMES
Aged 15 years, 8 months and 4 days

The Funeral will take place from the family residence in Gardnerville, on Thursday, April 12th, 1906 at 1:30 P. M. Services in the Lutheran Church at 2 P. M.

Friends and acquaintances are invited to Attend.

Interment In Garden Cemetery

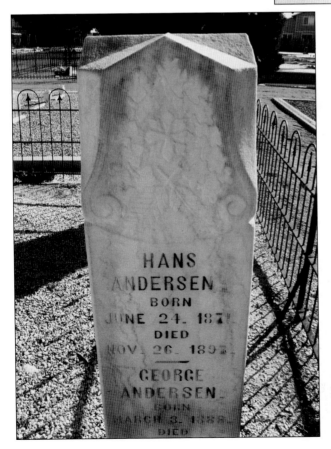

HANS
ANDERSEN
BORN
JUNE 24, 187
DIED
NOV 26, 189

GEORGE
ANDERSEN
BORN
MARCH 3, 1
DIED

In the early morning of November 26, 1897, Hans Andersen, floor manager of the Thanksgiving Ball and Turkey Shoot, was shot by Adam Uber during a dispute over 25¢. Uber claimed self-defense, but he was arrested and placed in the Genoa jail.

Thanksgiving Ball

—AND—

TURKEY SHOOT,

—AT—

MILLERVILLE,

Thursday, November 25th, 1897.

MUSIC BY TAYLOR'S BAND.

Grand March Begins at 8 O'clock.

FLOOR MANAGERS: WILL RITCHFORD AND HANS ANDERSON.

Tickets, to Ball and Supper (Horse Feed Free), : : : : : $2.

ALL ARE CORDIALLY INVITED.

This advertisement heralded the event that led to the death of Andersen, as seen in the *Genoa Weekly Courier.* Andersen was a popular young Dane and brother of the proprietor of the Millerville Hotel and Saloon.

ADAM UBER, THE MURDERER LYNCHED BY A NEVADA MOB

Said to be the "blackest episode in Nevada history," an angry mob stormed the Genoa jail, dragged Uber outside, then stripped and lynched the man. Uber pronounced a curse on seven generations of the men responsible for his hanging. He was buried in an unmarked grave in the Genoa Cemetery. (DCHS.)

Known locally as "the curse of the hanging tree," a marker was fastened to the tree's trunk as a reminder to visitors of the gruesome event that took place. For many years, a dramatic presentation was made at sites of the actual events within the community of Genoa. (DCHS.)

"On this tree, early morning November 25, 1897 occurred the blackest episode in the history of Nevada. Adam Uber of Calaveras Co., Ca., was forcefully taken from jail, abused & hanged by an angry mob, for the pistol killing of Hans Anderson, a local teamster in a Millersville bar room brawel."

At the gravesite of Willie Dangberg, no mention is made of his murder at the hands of Indian Joe Pete in 1899. Dangberg was the 16-year-old son of a prominent valley ranching family.

FOULLY MURDERED

Will Dangberg Killed by a Drunken Indian.

ON THE TRAIL OF THE ASSASSIN

Making Towards Antelope Valley —When He Is Caught He May Get Short Shrift.

News reached Reno yesterday of a fatal shooting affray that took place in Carson Valley Thursday. An Indian that worked on the Fred Dangberg ranch in Carson Valley got into an altercation with another Piute, who hailed from Antelope Valley, Cal. The latter Indian was drunk, and flourishing a gun. Will Dangberg, son of the owner of the ranch, attempted to drive off the intruder, who fired, and Will fell with a bullet in his brain.

A physician was summoned from Gardnerville, but before he arrived the boy was dead.

A posse was quickly gathered and on the trail of the murderer, who fled toward Mono county. If he is overtaken there will be a good work quickly done.

The funeral of the murdered boy will take place in Gardnerville today.

BREVITIES.

"Foully Murdered" was the headline of the story about the murder of Willie Dangberg, as published in the *Nevada State Journal* on September 1, 1899.

Joe Pete Escapes.

The following account of the escape of Joe Pete, the Indian murderer, is taken from the Carson Appeal.

Late Sunday afternoon word was received from Genoa announcing the escape of Joe Pete, the murderer of William Dangberg, who is under sentence of death, the execution billed for May 4th.

To say that the escape of the redskin created excitement and comment here would place it mildly. Everyone naturally wondered how the Douglas officials could in any manner become careless enough to allow the murderer to slip through their jail. The story of the escape as it reaches Carson, seems to make matters worse.

He dug his way out of the place, which is reported a mere shanty, and covered the dirt taken out by excavating with his blankets. He must have been at work several days, as the amount of work performed could not have been done in a few hours.

Sheriff Brockliss headed a party that started on a hunt for Pete and the sheriff has also offered a reward of $50 for his capture. It is not likely that many people will offer themselves as a target for Pete's marksmanship for this munificent reward.

The fact that Governor Sadler has refused to interfere in the execution of the murderer, should have made the officials of Douglas confine the Indian in the steel tank constructed for characters of Pete's nature.

The attorneys for Pete now have a petition before the Supreme Court for a new trial, and the fact that Joe Pete has escaped will not prevent the hearing of the petition.

Up to last night there had been nothing heard from the escape, and it is hardly likely that he will be captured in a rush, as he realizes he is under sentence of death.

Word was received from Gardnerville yesterday which indicates that the people on that side of the valley don't view the escape of the murderer in a very favorable light. The commissioners paid the reward money on the former capture and offered a new reward of $800 for Joe Pete, dead or alive. The citizen reward and likewise the Dangberg reward were paid. It is also likely that Sheriff Brockliss will be called be-

"Joe Pete Escapes," reported the *Nevada State Journal* on April 4, 1900. The newspaper article covered Joe Pete's escape by way of excavation from the Genoa jail. The sheriff offered a reward of $50, later increased to $800, for the capture and return of the murderer.

$800. $800.
REWARD!

OFFICE BOARD OF COUNTY COMMISSIONERS,

Douglas County, Nev., April 2, 1900.

RESOLVED, That we, as Commissioners of Douglas County, Nevada do Offer a Reward of

Three Hundred Dollars

For the Re-capture and Delivery to the Sheriff of Douglas County, of Joe Pete, Indian, Convicted of Murder, to be Paid to any Person or Persons who Shall so Apprehend and Deliver the said Joe Pete, Indian, Dead or Alive to the Sheriff of Douglas County.

NOTE—Joe Pete is a Washoe Indian, between 28 and 30 years of age. He is about 5 feet 8 inches in height, solid built and weighs about 160 pounds. He has scar under one or both jaws, first finger on right hand is stiff and there is a scar between the first finger and thumb, has a mustache, and has tattoo marks high up on forehead. When last seen was wearing blue overalls, light shirt, blue jumper, wore about No. 8 shoe.

N BLOSSOM, J. RODENBAH,
CLERK. COMMISSIONER.

In addition to the above $300 reward offered by Douglas County, I offer a reward of

$500

to any person or persons who will deliver said Joe Pete, Indian, to me at Genoa, Nevada, Dead or Alive.

J. F. BROCKLISS,
Sheriff Of Douglas County, Nevada.

The reward poster for Joe Pete offered an "$800 reward . . . for the re-capture and delivery to the sheriff of Douglas County, of Joe Pete, Indian, convicted of murder, to be paid to any person or persons who shall so apprehend and deliver the said Joe Pete, Indian, dead or alive."

KILLING OF JOE PETE

The Outlaw Passes in His Checks and Is a Good Indian Now.

Joe Pete,' the Indian outlaw of Douglas—the red skinned terror—who has evaded posses, defied law and terrified his own tribe, has at last fallen victim to the promitive code of Indian warfare—an eye for an eye and a tooth for a tooth.

He is dead. Shot to his death by one of his own tribe, his brother, not as the avenger of justice, but a victim to the crude simplicity and strange loyalty of his own kin.

Joe Pete is the Indian, who late in 1889 shot and killed Willie Dangberg, at Dangberg ranch. Many attempts were made to get him and none succeeded. Finally he was caught, tried, convicted, sentenced and again escaped.

A few days since he killed his father-in-law. Traps, decoys and ambuscades were prepared and had not his own brother, to prevent him from falling into the hands of the whites, killed him as was about to place himself in the hands of his friends in ambuscade. He would have died at the law's command.

His instinct was killing. His passion was blood. His delight was death; and as an outlaw he lived in the woods and defied the customs of his tribe and the laws of our government.

It is a pity that' around his villainous neck the tightened hemp of justice could not have strangled him.

"Joe Pete, the Indian outlaw of Douglas . . . is dead. Shot to death by one of his own tribe, his brother, not as the avenger of justice, but a victim to the crude simplicity and strange loyalty of his own kin." The brother delivered Pete's body to the sheriff; however, no record indicates if he collected the reward money. This article ran in the *Nevada State Journal* on October 10, 1901.

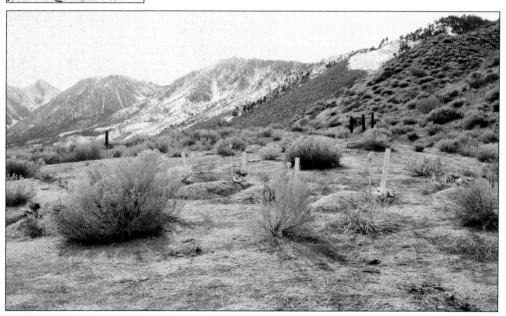

At the Captain George Indian Cemetery, both marked and unmarked graves are located. Some of the marked graves have the family name of Pete inscribed on them. Could one of the unmarked graves hold the remains of Indian Joe Pete?

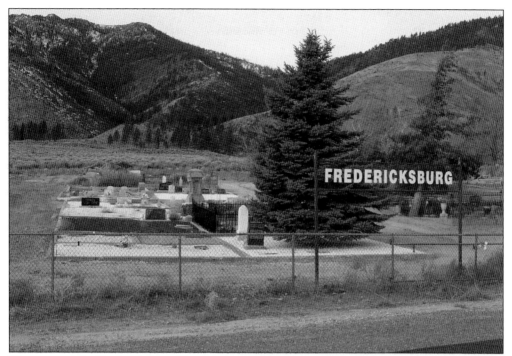

The gates of the Fredericksburg Cemetery are located near the county line of Douglas County, Nevada, and Alpine County, California. Buried here are members of early ranching and pioneer families, and the cemetery is still used by descendants of those families today.

Joseph Larson was a hotel keeper in Monitor, California, born in Norway. He died in 1898, and his obelisk monument includes a carved city and clouds indicative of heaven. The inscription is a biblical verse, "In my Father's house are many mansions." Larson is at rest in Fredericksburg Cemetery.

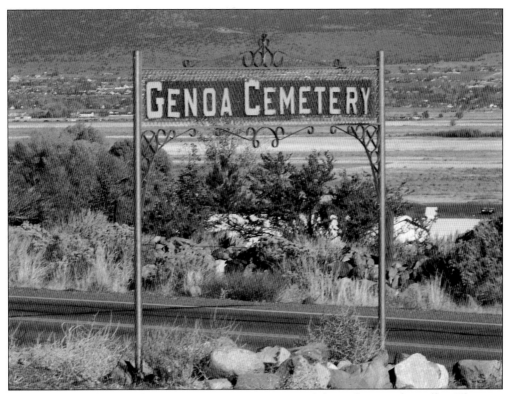

Located on Foothill Road is the Genoa Cemetery, one of the earliest in the valley. The gate stands alongside the roadway.

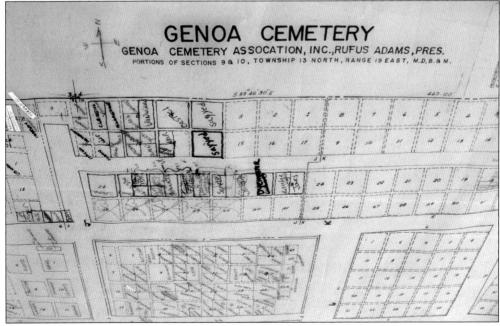

A portion of a map of the Genoa Cemetery, compiled by the Genoa Cemetery Association, is pictured. The association maintains the grounds and sells plots. (Genoa Cemetery Association.)

The ground for the Genoa Cemetery was deeded to the community by James W. Haines. Haines served as a state senator and was active in the valley. His bereavement card indicates he was a member of the Masons, a native of Canada, and 73 years old at the time of his death in 1900. Haines was buried in the Genoa Cemetery, but his family later moved his body to another location. (DCHS.)

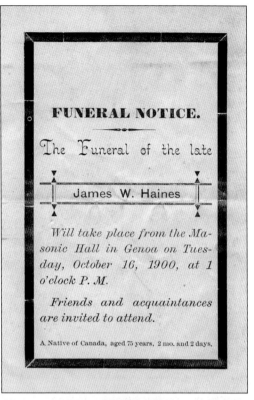

FUNERAL NOTICE.

The Funeral of the late

James W. Haines

Will take place from the Masonic Hall in Genoa on Tuesday, October 16, 1900, at 1 o'clock P. M.

Friends and acquaintances are invited to attend.

A Native of Canada, aged 75 years, 2 mo. and 2 days.

The Van Sickle plot in the Genoa Cemetery holds the remains of members of the family and in-laws. The unremarkable stone does not reveal any of the fascinating stories of the Van Sickle family.

Henry Van Sickle arrived in Carson Valley in 1852. In 1857, he built Van Sickle Station, which included a blacksmith shop, barns, a saloon, hotel, and eventually a house. He was married twice and had eight children. Van Sickle is famous in Nevada history for killing Sam Brown, an infamous murderer, on July 6, 1861.

The gravesite of Charley Vansyckle [sic] is located in a pasture next to the main building of Van Sickle Station. Charley was the fourth child of Henry and his first wife, Mary. Mary Gibson Van Sickle bore four children and was pregnant with her fifth child when she was reported as "going over the mountain" to California. She never returned, and no record has been found of her fate after leaving Nevada.

In a corner plot in the Genoa Cemetery, a block of rose quartz engraved "Bill" stands as the memorial for Bill Zirn. Zirn was from Germany and was drawn to America by the promise of a better life. He was a prospector and, in 1891, finally made the big strike in the Pine Nut Mountains. Tragedy struck in June 1896 when a large boulder broke loose and hit Bill, crushing him to death. Legend claims that the rock used as his marker is the same rock that killed him.

Zirn and Monarch Mines

FISH SPRINGS

BUCKEYE RD.

FLAT

TO BUCKEYE CR.
2.1 MI.

ZIRNVILLE

OREANA CLAIMS

PINE NUT RANGE

5862'

MONARCH MINE

PETE ANDERSON RANCH

6070'

US 395
3.7 MI. 5200'

PINE NUT RD.

OLD PINE RD.

5600'

PINE NUT CR.

N

TO PREACHERS MINE 0.5 MI.

TO MILL CAN.
2.5 MI.

0 1 2 3

Douglas County, Nevada

The Pine Nut Chronicle includes this map of Zirnville, the community that grew around the major gold strike located by Bill Zirn in 1891. (Nyle Nation.)

A native of Ohio, William Cradlebaugh came to Nevada in 1859. His draped stone, a symbol of respect, reveals that he was a veteran of the Mexican War in 1846. Cradlebaugh rests in the Genoa Cemetery.

90

Cradlebaugh constructed a bridge crossing over the Carson River in 1861. The bridge considerably shortened the distance between the booming mining districts, greatly improving transportation. (DCHS.)

A young man named George W. G. Ferris Jr., inventor of the Ferris wheel, was said to be inspired by the large undershot water wheel near the Cradlebaugh Bridge. The Ferris wheel, an engineering marvel, was unveiled at the Chicago World's Fair in 1893. (DCHS.)

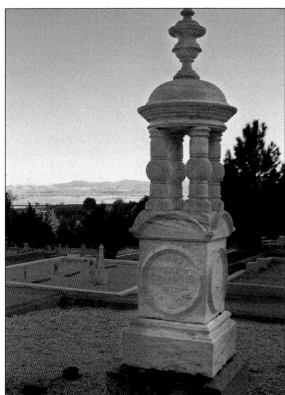

David E. Walley and his wife developed a hot spring spa and resort in 1862. The waters were a "cure of rheumatism and scrofulous affections." His unique marble monument is easily found in the Genoa Cemetery.

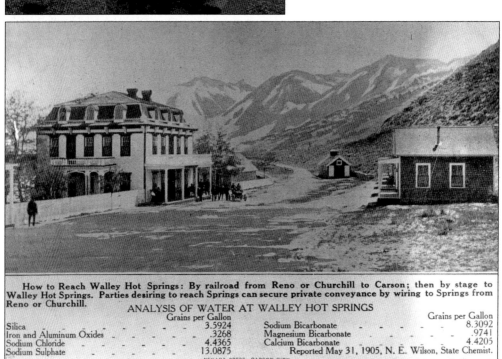

How to Reach Walley Hot Springs: By railroad from Reno or Churchill to Carson; then by stage to Walley Hot Springs. Parties desiring to reach Springs can secure private conveyance by wiring to Springs from Reno or Churchill.

ANALYSIS OF WATER AT WALLEY HOT SPRINGS

	Grains per Gallon		Grains per Gallon
Silica	3.5924	Sodium Bicarbonate	8.3092
Iron and Aluminum Oxides	.3268	Magnesium Bicarbonate	.9741
Sodium Chloride	4.4365	Calcium Bicarbonate	4.4205
Sodium Sulphate	13.0875	Reported May 31, 1905, N. E. Wilson, State Chemist.	

NEVADA PRESS, CARSON CITY.

Walley Hot Springs Resort, still in operation, is shown in this 1905 photograph that includes an "analysis of water at Walley Hot Springs."

The black granite obelisk marker dedicated to the Adams family is located in the Genoa Cemetery and includes information on many family members. The Adams home is built of brick that was made in kilns on the family ranch.

John Quincy Adams, a brick maker by trade, and his brother, Rufus, engaged in the brick trade and supplied material that was used to construct the U.S. Mint in Carson City and the Douglas County Courthouse in Genoa. Adams married Ellen Dolan in 1866. The family traces its roots to the second U.S. president of the same name.

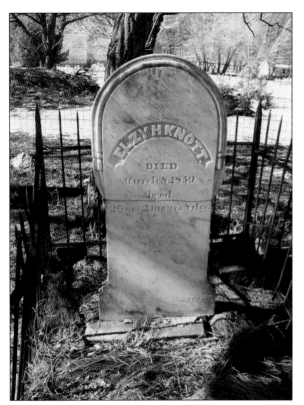

This headstone and fence mark the burial site of Elzy Knott, a young man of Genoa. His father buried his son behind his property rather than have him buried in the "Mormon" cemetery grounds. Elzy was killed following an argument with a Mormon youth in March 1859.

Elzy Knott was a young man of 26 at the time of his murder. Knott was killed by a teenage boy, whom he had argued with earlier in the day over ownership of a horse bridle they had gambled over. (DCHS.)

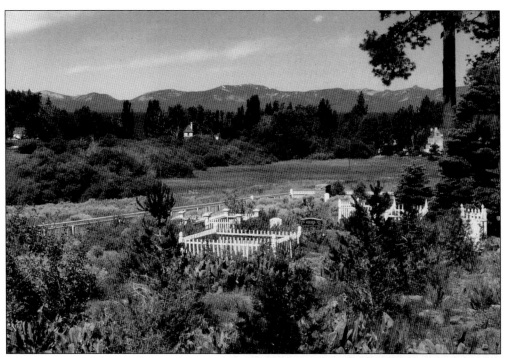

This is a view of the small fenced cemetery located at Glenbrook, on the shore of Lake Tahoe. Most of the markers date from the early settlement period when sawmills and a system of rails and flumes supplied lumber to the Comstock mines and towns.

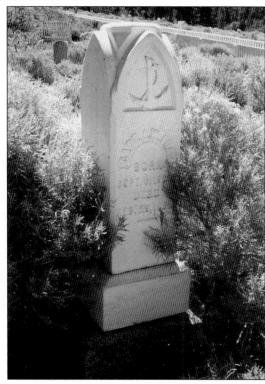

Capt. Augustus W. Pray built the first sawmill and hotel at Glenbrook. By 1877, he owned over 4,000 acres of timber. His obituary noted that he was "at one time one of the wealthiest men on the shores of Lake Tahoe." His marble gravestone, which carries the inscription "this mortal must put on immortality," is found in the Glenbrook Cemetery.

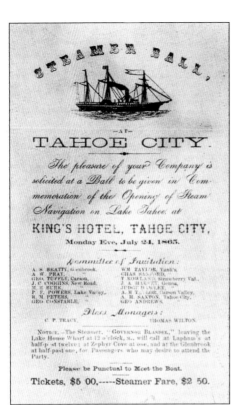

The first Steamer Ball, held at Lake Tahoe on July 24, 1865, included Capt. A. W. Pray on the Committee of Invitation. The steamer *Governor Blaisdel* was financed and named by Captain Pray in honor of the first governor of Nevada. It should be noted the correct spelling is *Blasdel*.

This wooden marker was erected on the gravesite of Frank Jellerson and his sister, Amanda Jane. Mr. Jellerson served as postmaster and proprietor of the Jellerson Hotel and the Dirego Hotel. Brother and sister rest in peace beside each other in the Glenbrook Cemetery.

Frank Jellerson's Dirigo Hotel, located south east of Glenbrook's
present golf course. Hank Monk's stage in the foreground.

The Jellerson Hotel at Glenbrook, built in 1882, was located near the present-day golf course.
Jellerson and his sister operated the Jellerson House and the Dirego Hotel for many years.

Located in the pines, the small cemetery in Jacks Valley was recently restored. Many of the
fences and gates are hand-forged iron. Records indicate that Mary Gardner, wife of John, sold
property to the Carson and Tahoe Lumbering Company for $500, with 167 square feet set aside
for a cemetery.

Within the fence of the Jacks Valley cemetery is the burial site of John M. Gardner, for whom Gardnerville is named. Gardner was a native of England who arrived in the Carson Valley in 1854, where he engaged in ranching.

IN MEMORIAM.

JOHN GARDNER.

Died on December 5, 1887, at Clear Creek, Nev. A Native of Preston, England. Aged 69 years, 9 months and 5 days. Buried December 6, 1887, at Jacks Valley Cemetery, Nev.

The bereavement card for John M. Gardner provides his location of birth and death and that he will be "buried December 6, 1887, at Jacks Valley Cemetery, Nev." (DCHS.)

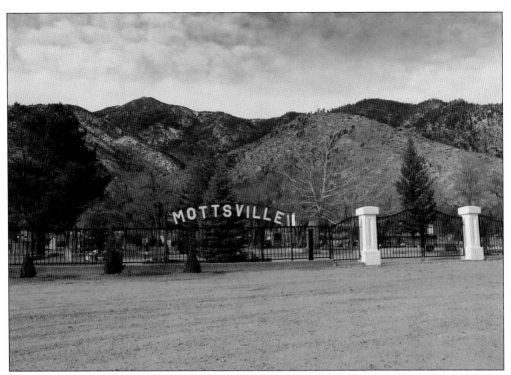

Mottsville Cemetery is all that marks the site of the community of Mottsville. Still in use today, the grounds hold the remains of many early Carson Valley families. The site is well maintained and surrounded by residences.

Dr. Eliza Cook, one of the earliest Nevada doctors, arrived in Nevada in 1870. Dr. Cook attended Cooper Medical School in San Francisco and received her medical degree in 1884. She returned to the Carson Valley, where she practiced medicine until her retirement at age 65 in 1921. Dr. Cook never married, rather devoting her time and talents to her family, friends, and causes such as women's suffrage. She is buried in Mottsville Cemetery. (NSM.)

One of the last photographs of Dr. Eliza Cook was taken in June 1947. She is seated in the front row, second from right. In 1896, Dr. Cook had written an essay, "The Woman Yet To Come," outlining her vision of women of the new century. Prior to her death, Dr. Cook wrote a one-page autobiography, "Outline of My Life." Dr. Cook died peacefully at home in Mottsville at age 91 on October 12, 1947. (UNRSC.)

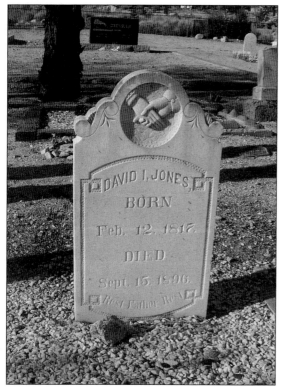

David I. Jones, born in Wales in 1817, immigrated to America and settled in Carson Valley. He and other family members were one of the earliest ranching families in the area. His headstone in the Mottsville Cemetery includes the symbolism of clasped hands and the epitaph "rest Father rest."

This is an early photograph of the David I. Jones family. Jones is seated in the front row, second from right. Many members of the Jones family are buried in Mottsville. The large marker erected to memorialize the Jones family claims that the patriarch and his wife, Mary, settled in the area in 1863, raised a family of five, and operated a freight line over Daggett Pass. (UNRSC.)

Chesnel DesIsle, born in Maine in 1833, arrived in the Carson Valley with his two brothers. He died in Mottsville at age 34 on February 2, 1865. His epitaph reads, "So fades the lovely blooming flower, cut down and withered in an hour." Chesnel's brother Isaac wrote the family back in Maine that he "purchase[d] a set of Tomb Stones for dear Bro Chesnel . . . I have given up the idea of getting an Iron Railing as they are about enclosing the Burying Yard, and as the Community will make that their Burying Ground they will keep the Fience [sic] in Repair." (DCHS.)

Ben Palmer was a prominent rancher in the valley and the first black pioneer to settle in the area. Arriving in 1853, Palmer settled on 400 acres of land and, by 1867, was described as "one of the heaviest taxpayers in Douglas County." This photograph shows Palmer astride his horse, talking with Mary Hawkins in the buggy. Palmer and his sister had been slaves in Missouri.

Ben Palmer's monument in the Mottsville Cemetery is part of a central burial site for the Palmer and Barber family. Here Palmer; his sister, Charlotte; and her husband, David Barber, alongside their seven children, rest in peace. Palmer died in 1908, and the newspaper reported, "one of Carson Valley's best citizens is dead." The Palmer Ranch is still in operation. The monument incorrectly spells the last name as *Parmer*.

Five

THOSE THEY BURY
WITH MOST CEREMONY

In 1872, Mark Twain wrote that to know a community one must observe its style of funerals and what manner of men they bury with most ceremony. His sage advice is the postscript for those men—and women—that were laid to rest with honor and the most ceremony.

At the Pioneer Cemetery in Carson City, a memorial dedication to the first lawman killed in the line of duty was held in 2009. Sheriff John Blackburn was honored by Carson's citizenry under the auspices of the Nevada Law Enforcement Officers Memorial Commission.

In Lone Mountain Cemetery, six Nevada governors are buried. The soldiers who served at Fort Churchill, a lonely outpost constructed to protect the citizenry from Indian attack, were buried there in the desert sand of the fort. Their bodies were reinterred in Lone Mountain Cemetery and provided a full military burial with distinction many years later. The Nevada legislature would fund the purchase of a white bronze memorial statue to honor Nevada's soldiers and sailors. The soldier has stood as a silent sentinel since 1891. In 2004, the statue would be restored and rededicated in a ceremony that echoed the honor and status of these men that time and the community had almost forgotten.

At the Genoa Cemetery, the Norwegian ski team took time out from participating in the 1960 Winter Olympics in Squaw Valley, California, to honor John "Snowshoe" Thompson. Snowshoe's fame extends far beyond Nevada into at least three memorial sites in California, one of which is in Los Angeles.

Let us not forget the admonition of Abigail Adams to her husband, John Adams, in 1776 to "remember the ladies." Among the many women to be honored in life and death are Annie H. Martin, Jennie Clemens, and Nellie Verrill Mighels Davis.

Annie Hudnall Martin arrived in Nevada at age six from Missouri. One of her childhood friends was Jennie Clemens, the niece of Mark Twain. Annie became a teacher in 1877 and was the first teacher of a kindergarten class in the state. After 13 years of teaching, she purchased the *Carson Daily News* and served as editor for four years.

In 1908, Annie was hired as a clerk at the U.S. Assay Office (formerly the U.S. Mint) in Carson City. By 1913, she had become chief clerk and, in 1921, was appointed by Pres. Warren G. Harding as assayer in charge— the first woman to hold this title and manage a U.S. Assay Office. Annie served in that capacity until her death in 1928. (NSM.)

DEDICATED TO THE MEMORY OF
ANNIE H. MARTIN
BY HER BEREAVED STUDENTS
AND CLASS-MATES, IN LOVING
REMEMBRANCE OF HER GREAT
DEVOTION, UNFAILING KIND-
NESS, UNSELFISH SERVICE
AND STERLING WOMANHOOD.

Annie never married, instead devoting her life to her career, family, and causes. A staunch anti-suffragist, she strongly urged women not to take up the mantel of politics and leave that to the "sterner sex." She was the First Presbyterian Church organist for 40 years, presented musical performances at the Nevada State Prison, and loved motion pictures. Annie was honored by the community at her funeral as the schools closed, the church organ was draped, businesses were shuttered, and many state officials attended her services at Lone Mountain Cemetery.

Jennie Clemens was the niece of Samuel Clemens, better known as writer Mark Twain. Born in Iowa in 1855, her family relocated to western Nevada Territory in 1863 when her father, Orion, was appointed territorial secretary by President Lincoln. Jennie's life was cut short by spotted fever on February 1, 1864.

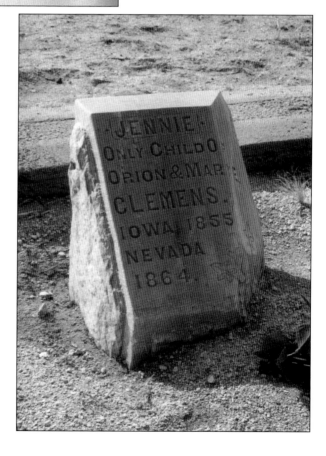

At the time of her death, Jennie was saving money to purchase a Bible for the First Presbyterian Church. The Bible's dedication page reads, "Presented to the 1st Presbyterian Church Carson City, Nevada. A Memorial, Miss Jennie Clemens. Miss Jennie died February, 1864. Afterwards, it was learned that she had been saving her money to buy a pulpit Bible for the new church. She was 10 years of age, and was laid to rest in Lone Mountain Cemetery." (NSM.)

Jennie's sandstone marker was cut from Curry's quarry. In her honor, the Nevada legislature adjourned so members could attend her services. Her uncle's grief would soon find an outlet in a published lashing of the undertaker in charge of Jennie's funeral. Jennie was one of the earliest burials made in the city cemetery that would later be consolidated as Lone Mountain Cemetery.

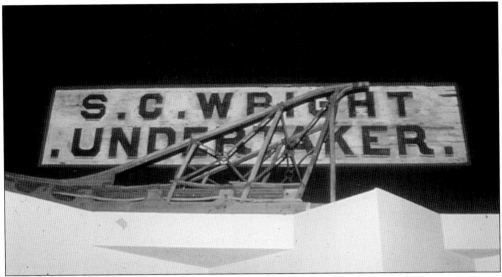

The business sign for Samuel C. Wright, the undertaker in charge of Jennie's funeral, is shown here. Jennie's uncle charged Wright with extortion and taking advantage of people in their time of sorrow. His scathing editorials culminated with the statement that "Mr. Curry says . . . a city cemetery can be prepared and fenced in a week from which a man can set out for Paradise or Perdition as respectfully as he can from the undertaker's private grounds." The sign is on display at the Nevada State Museum in Carson City.

Nellie Verrill Mighels Davis, born in Maine in 1844, was orphaned by the age of 16. Nellie married Henry Mighels, the newly appointed editor of the *Carson City Morning Appeal*, in 1864. Nellie's cross-country trip was via the Isthmus of Panama, riding the narrow gauge railroad, by steamer to San Francisco, and finally by stage coach to Carson City, with Hank Monk at the reigns. Mighels was the editor of the *Carson City Morning Appeal* until his death in 1879. At 35 years old, Nellie became the editor of the newspaper. She was the first woman to cover the proceedings of the Nevada legislature and was an incognito reporter at the Corbett-Fitzsimmons fight in 1897. Nellie married Sam Davis in 1880.

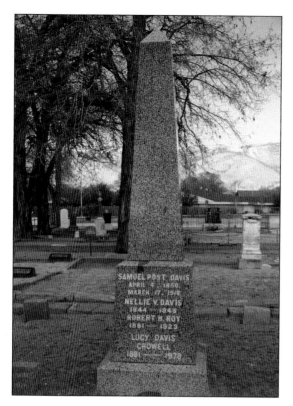

Nellie was actively involved in events both locally and on a nationwide scale. Her accomplishments over a lifespan of 101 years included organizing the Nevada Red Cross, founding and acting as president of the Leisure Hour Club, assisting in legislation giving equal rights to mothers in the care and custody of a child, and establishing a home for delinquent children at Elko, Nevada. Nellie died in 1945 and is buried with her family in Lone Mountain Cemetery.

John "Snowshoe" Thompson arrived in America from Norway in 1837. In 1851, he crossed the plains to California and settled in Placerville. He applied for what was to become his new career after noticing an advertisement in a newspaper declaring, "People to the lost world: Uncle Sam needs a mail carrier!" Snowshoe built a home for his family near Markleeville, California, in 1859. His accomplishments are legendary.

SNOWSHOE THOMSON

Scion of mighty Vikings;
 Master of drifted snow;
With only the stars to guide you
 And the instinct of where to go,
On! On you pressed toward summits!
 On! On with the precious mail!
Climbing, yea, ever upward
 Over the blinded trail.

The whistling blizzards fought you,
 And the teeth of the biting cold,
But you faltered not, John Thomson,
 For the will, inside, was bold.
From Hangtown on to Carson
 Your hand hewn skiis have gone,
The ancient pines that whisper
 Tell, often, what you've done.

Strawberry's cave still echoes,
 And the Lovers' Leap resounds,
Strange voices in the offing -
 As, by night, your swift ghost bounds
Genoa breathes your spirit;
 Up where the blizzards rage
There's a voice in the high Sierra
 That sings to Nevada's sage.

Pony Express Historical Series - No.
by White Fox Skyhawk -

This poem was written to honor Snowshoe Thompson. Thompson was never paid by the U.S. government for his extraordinary service after trekking across the Sierra over 90 miles each way between Genoa, Nevada, and Placerville, California, for more than 20 years. The only compensation he received was from grateful individuals along the route.

In 1876, Thompson suffered an appendicitis attack, which eventually developed into pneumonia. He died at the age of 49 on May 15, 1876. The newspapers wrote lengthy obituaries describing his accomplishments and paid tribute to the Old Man of the Mountains. (NHS.)

Died

In Diamond Valley, Sunday, February 21, 1915

Agnes Thompson-Scossa

Native of Preston, England
Born November 4, 1831

The Funeral Services will be held from the Masonic Hall, Genoa, Tuesday, February 23, at 2 o'clock p. m.

Friends and Acquaintances are Invited

Interment in Genoa Cemetery

Thompson married Agnes Singleton in 1866. Their only child, Arthur Thomas, was born in 1867 but died of diphtheria in 1878. Agnes married John Scossa in 1884. Her mourning notice reflects her continued usage of Snowshoe's last name as part of her own. The Thompson family is at rest in the Genoa Cemetery.

Snowshoe Thompson has the distinct honor of being memorialized in many locations in California and Nevada. This bronze sculpture is located at the Boreal Ski Resort in California, while a similar sculpture was dedicated in Genoa, Nevada, in 2001.

Lone Mountain Cemetery is the final resting place for six Nevada governors. John Kinkead served as the third governor of Nevada (1879–1883) and the first territorial governor of Alaska (1884–1885). He was politically active in the formative years of the territory and state of Nevada.

Governor Kinkead and his wife, Elizabeth, are buried beneath a Celtic cross monument. The inscription on his stone reflects his service as governor of Nevada and Alaska. Kinkead also served as the first postmaster of Sitka, Alaska, receiving the handsome salary of $12 per year.

Pictured at the Midwinter Fair in San Francisco in 1894 are three Nevada governors. From left to right are Henry Blasdel, Nevada's first governor (1864–1871); Roswell Colcord (1891–1895); and John Kinkead (1879–1883). (NSM.)

Roswell Colcord served as Nevada's seventh governor from 1891 to 1895. During his tenure, the state board of health was created and women's suffrage was debated. Following his term as governor, Colcord was appointed as superintendent of the U.S. Mint (and U.S. Assay Office) in Carson City, a post he held from 1898 to 1911.

Colcord was honored by the U.S. Senate on his 100th birthday in April 1939. In an interview, he noted that he did not follow any special diet that would account for his longevity and that he voted for every "Republican candidate for President from Lincoln to the present," which at the time was Herbert Hoover. Colcord died on October 21, 1939, the same day as Nevada's Diamond Jubilee anniversary.

This photograph was taken during the term of office of Gov. Emmet Boyle, who served from 1915–1923. Pictured are, from left to right, former governors Colcord (1891–1895), Tasker Oddie (1911–1915), Boyle, Denver Dickerson (1908–1911), and Jewett Adams (1883–1887). (NSM.)

Nevada's 11th governor, Denver Dickerson, was born in California and arrived in Nevada following his enlistment in the Spanish-American War. He was a newspaper editor in Idaho and Nevada prior to entering public service. Dickerson was first elected to office as the White Pine county clerk-recorder (1904–1905), then lieutenant governor (in 1907), and later became acting governor upon the death of Gov. John Sparks in 1908.

Governor Dickerson's military marker indicates his service in the Spanish-American War. The stone does not reflect his public service record or other biographical information. After his term as governor, Dickerson was appointed warden of the Nevada State Prison (1911–1925).

GOVENOR'S MANSION CARSON CITY NEVADA
No38

Prior to 1909, Nevada governors did not have an official home, instead using their own residences. In 1907, the Nevada legislature appropriated $40,000 for building and furnishing an executive mansion. The mansion was completed in July 1909, and Governor Dickerson and his family were the first occupants.

Reinhold Sadler was born in Prussia in 1848 and moved to America in 1864. He settled in Eureka, Nevada, working as a miner and merchant. He was elected Eureka County treasurer (1880), lieutenant governor (1895–1896), and assumed the duties of governor following the death of Governor Jones in 1896, running for the office successfully in 1898.

115

Governor Sadler was responsible for legislation in 1897 that called for the licensing of prizefights in Nevada. Known as the Glove Contest Bill, the legislation called for licensing fees, with a portion going to the county where the event was held and a portion to the state general fund. On March 17, 1897, the Corbett-Fitzsimmons fight was held in Carson City—the first licensed boxing event in the state.

Governor Sadler died in Eureka, Nevada, in 1906 and was interred in Lone Mountain Cemetery. For a quarter century, Sadler was a prominent political figure in Nevada. His biographer wrote, "He was an eccentric man and spoke with a German accent, but it is generally conceded he was one of the best business governors the state ever had."

Born in Wales in 1840, John E. Jones arrived in the United States in 1856. By 1869, he was living in Eureka, Nevada, and engaged in mining and ranching. Jones was elected Nevada's eighth governor in 1895 as a Silver Party candidate. His inaugural ball was reportedly not well attended due to political reasons. During his term of office, Nevada's first public library was created in Reno.

Governor Jones did not live through his term of office, dying of cancer in 1896. According to a biographer, what his inaugural ball lacked was made up for by attendance at his funeral in Carson City. The governor's body lay in state in the capitol, and all of the city's churches and choirs participated in the funeral service. His cortege was estimated at two miles long, with the president of the university delivering the eulogy and the Masons conducting the graveside services.

Tasker Oddie was a New York lawyer sent to Nevada in 1898 to handle mining issues for a client. Oddie later became a mining entrepreneur, playing a significant role during the Tonopah-Goldfield mining boom. Oddie was elected as Nevada's 12th governor in 1910.

Oddie ran successfully for U.S. Senate in 1920, a position he held until 1933. As governor and senator, Oddie promoted roads and highways, the mining industry, and the placement of the munitions depot in Hawthorne, Nevada. He died in San Francisco in 1950, and his body was returned for burial in Lone Mountain Cemetery.

At the now-abandoned cemetery of Fort Churchill lay the "unknown dead"—soldiers who died while in military duty from 1863 to 1866. Each grave had been marked with a wooden headstone, but for the majority, their identification had weathered away. In 1884, Congress appropriated $1,200 to move the bodies to Lone Mountain Cemetery in Carson City. (UNRSC.)

On February 16, 1885, the bodies of 36 soldiers from Fort Churchill were reinterred in the Grand Army of the Republic (GAR) plot in Lone Mountain Cemetery. A large parade of military contingents, dignitaries, schoolchildren, and state and local officials attended the event. Tributes, speeches, and military ceremony reigned on this day in honor of the forgotten men.

In 1891, the Nevada legislature appropriated $1,000 for the purchase and erection of a monument in memory of the deceased soldiers and sailors of the late war (Civil War) buried in the cemetery in Carson City. The Monumental Bronze Company was selected to create the monument, a 6-foot-tall Union solider in greatcoat and kepi hat, standing at parade rest. The monument was unveiled on May 30, 1891. (NHS.)

The last surviving members of the Grand Army of the Republic Custer Post No. 5 pose at the monument during Memorial Day services held in 1920. The flagpole was donated in 1919 by a member of the GAR.

In 2000, a grant was secured to provide much needed restoration work on the Civil War monument. Over the years, the statue had been shot at and vandalized with graffiti. On July 19, 2004, under the careful watch of interested parties, the statue was dismantled and sent off to a foundry in Cincinnati for repair.

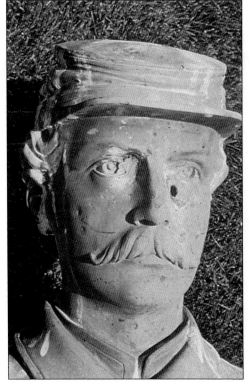

Here is a close-up view of the face of the soldier, displaying the damage near both eyes. Suffering from decades of neglect in the cemetery, the statue had been used for target practice by youths with no thought as to the significance of the sculpture. Restoration work included repairing chips and cracks, structural improvements, and the addition of a sealant to protect the exterior.

The monument was returned to Lone Mountain Cemetery in November 2004. The reassembly began immediately, a time capsule was placed inside the monument, and plans were made for the rededication of the statue. The rededication event was held November 11, 2004, with the inclusion of an honor color guard, supplied by the Sons of Union Veterans of the Civil War.

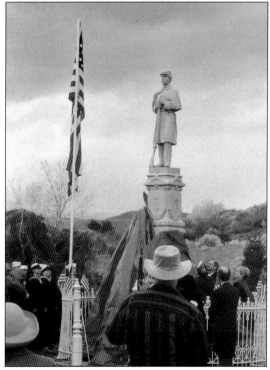

The refurbished monument was unveiled to the community following presentations and speeches by those who were responsible for returning the statue to its historic site and in rehabilitated condition. A granite marker was placed near the monument with the inscription, "Now free of damage and the ravages of nature and mankind the sentinel soldier returns to his solitary duty of standing watch over the historic veterans' section of Lone Mountain Cemetery."

In December 1859, John Blackburn married Sarah Peirson, an accomplished music teacher in the community. By the age of 20, she had become a widow facing financial difficulties. Sarah petitioned the Territorial Legislature for her deceased husband's salary, and they approved $936.50 for those services. (NSM.)

John and Sarah had a daughter, Minnie, born less than a year prior to John's death. Minnie lived out her life in Carson City, becoming a schoolteacher alongside her friend, Annie H. Martin. Minnie died at age 22 in 1881 and is buried in Lone Mountain Cemetery. (NSM.)

SHERIFF JOHN L. BLACKBURN
CARSON COUNTY
NEVADA TERRITORY
NOVEMBER 18, 1861

THE 1ST NEVADA LAWMAN KILLED IN THE LINE OF DUTY WAS SHERIFF JOHN L. BLACKBURN. THE SHERIFF WAS STABBED TO DEATH IN CARSON CITY'S ST. NICHOLAS SALOON WHILE ATTEMPTING TO ARREST WILLIAM MAYFIELD. MAYFIELD WAS CONVICTED OF THE MURDER AND LATER ESCAPED FROM THE TERRITORIAL JAIL. THE SHERIFF WAS LAID TO REST HERE NEXT TO HIS FRIENDS, MAJOR WILLIAM ORMSBY AND WILLIAM ALLEN WHOM HE SERVED WITH DURING THE 1860 PAIUTE INDIAN WAR.

NEVADA LAW ENFORCEMENT OFFICERS MEMORIAL COMMISSION 2009

The memorial service for John Blackburn included the dedication of a new plaque that was attached to the large cross marking the Pioneer Cemetery site. Note that Blackburn served with Major Ormsby and William Allen during the Pyramid Lake War. In addition to this new memorial, Blackburn's name is the first name etched in the marble State Law Enforcement Memorial on the legislative complex mall. Before arriving in Nevada, Blackburn's life is not well documented.

"Rest" is the message on this final epitaph.